DENIS GRRR

Apocryphorgy

MONDO BIZZARRO PRESS

Apocryphorgy

Copyright > © 2001 Mondo Bizzarro S.a.s./Last Gasp of S. Francisco
Copyright > © 2001 Denis GRRR
Text Copyright > © 2001 L. Bramardi

First edition > November 2001
ISBN: 88-87581-14-2

All rights reserved. No part of this book may be reproduced or utilized in any form or by any means,
electronic or mechanical, including photocopying, recording, or by any information storage and retrieval system,
without permission in writing from the publisher.

Published by **Mondo Bizzarro Press** - Via Alessandrini 7 - 40126 Bologna - Italy
Tel/fax: [+39] 051.243.438 www.mondobizzarro.net
and by **Last Gasp of San Francisco** - 777 Florida st. - San Francisco, CA 94110 - USA
www.lastgasp.com

Design > **Atos Coppi**.
English text translations > **Annie Dauphine, David Sheen, Richard Rice**.
Printed and bound in Italy.

Thanks to > **S. Heuze, MDS, NeSS, Mr. PLUS, T. Gayrard, Leo/Bat**.

D. GRRR / PAL - WED
69, rue d'Avron
75020 Paris – France
www.welcom-technology.com/dgrrr

> "The essential thing is the image, the image freed from its own legend, freed from any comment. The image that is its own totality."
>
> D.GRRR in *Hesodia*.

The image speaks for itself. Fine. So presumably we could leave it at that. But even if the message of the image is obvious, that is not enough to explain its presence. It tells us nothing of the context in which it was born, nothing of its creator's journey, nothing of the image maker, nothing of its own status or time. Time spent on the stage or lost courting schemes that turn to delusion after the ingratitude of days, after misappreciation and premature rejection. This is the time of our century, the conclusion of an era that we have condescendingly labelled «modern», as today, we too have rightly become «post-modern». The generation of the image that has forgotten the real world that pre-existed it. Here we stand, and the desire to discover from where inside us GRRR's wild and exultant visions spring has become a need. They speak to us of a truly fictitious world, fictitious enough to draw conclusions about the real world, but with what right?

That was established last century, when the image was a parable. Rarer and still distinct from the photography that was destined to replace it, the image spoke of a greater, foreign world, while mocking the propensity of modernism. Rops, amongst others, has certainly influenced GRRR, and with him the entire wave of counter-opinion raised in public protest against budding pragmatism, as if the rise of consumerism and the end of meaning had been foreseen. Not by chance, at this time Symbolism was gaining credence and new anatomical reproductions could be found on the walls of erudite cabinets. At first the body was chastely covered, but it was soon left naked, then it lost its skin, its muscles, until only the blood vessels remained, only the nerves, only the genitals. Two possibilities exist here, but the phallus is always in the foreground and the child in the uterus is almost inevitable. I have seen similar images on the crowded walls of GRRR's flat, but the irony and the anger of the figures spoke of the fascination of this strange mechanical representation, and of the cynicism towards an oppressive social order, slowly whittled away with every brush stroke.

The pen is no longer sufficient, even if it is the first weapon to be used against the whiteness of the page, against the isolation of nothingness. Today it is the brush that must move between the artist's fingers and colour must flow gradually, in harmony with the subjects that evolve ("*I would opt for something more refined, sensual or orgiastic*"[1]). The triumphant stroke must also prevail, the harsh, decisive, black line. No half tones here, these images have something of the starkness of a photocopy, the clarity, and direct expression of a stain. Here again we turn with the wheels of this era; progress is the means and we cannot ignore it. The copy has gained credence, the object alone no longer suffices. First the photocopied Fanzinat, then the printed illustration and the T-shirt. If the drawing complies with the stroke, then the whole composition adapts too, with the effectiveness of a page that has evolved from the world of comics, journalism, and the raw power of tattoo symbolism. Repetitions, flat black tints, tribal arabesques, a study of figurative space all help shape the subjects of GRRR's art. Often these subjects are so strong that it becomes difficult to identify the entire process that enhances what is already remarkable. Here, front-stage actions are highlighted by flat space and placed in an unrestricted, sacred and iconographic world.

So, a relationship of sense can be noted, a direct line between contemporary style and the witty, fashionable dissidence of the last century. Symbolism may be dead but today, self-defined Necrorealism can tell us what we need to know. This is what GRRR and his confederate T. Gayrard have decided as it has become too difficult today to overcome indifference. We want to shock, but we turn our eyes away. Nothing more. Blasphemy when we have forgotten the Church, pornography when we scoff at over-consumed sex, parables when we interpret the world using the TV as a hand-book. "*It is easier to shock than to question taboos, in this milieu that surrounds us*"[2] says GRRR. His images are excessive like the pictures they portray, in order to remind us that spirituality still exists when boundaries are crossed. People may no longer recognise this need, but that should not prevent us from shouting at indifference.

ANNO MCMXCIII

Le Necro Realisme

« Le Christianisme a donné un poison à boire à Éros. Il n'en n'est pas mort, mais a dégénéré en vice ». Nietzsche.

L'Armageddon joussif et graphique des chairs humaines. Prières Obscures mises à plat par d'étranges enlumineurs. Sujets tabous, Traités de manière Sensuelle et Esthétique, incluant la Pornographie Antique et Païenne.

Le Nécroréalisme, c'est la Déification de la femme, le retour à l'Erotisme sacralisé, c'est la Mémoire atavique qui se souvient des corps en-chevetrés, brulant dans l'amère saveur du Blasphème qui anihile la Mort.

L'image peut-être brute et sincère, Là où elle se suffit à elle même, que cela soit du montage photographique, ou quelques pinceaux chirurgicaux œuvrant sur des chairs offertes ou créant des corps galbés aux Seins Bibliques.

Un mouvement où l'Interdit et l'Extrême se rejoignent et convergent vers un unique objectif : la Transfiguration par l'art du premier cri : Clamor Primus.

Necroincubatorz : D. Serra
T. Grynard

Post-Mortem : le P.A.L. [Pornographic Aftermath Laboratories] et Indecent Exposures sont des supports contribuant au développement et à la connaissance de cet art Apocalyptique.

Indecent Exposure
8 CHEMIN DE LA BOURIOTTE
81 430 VILLEFRANCHE D'ALBI

P.A.L.
69, Rue d'Avron
75020 PARIS

Necro Realism

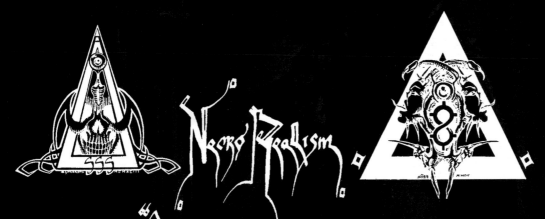

"◊ Christianity has given Eros a poison to drink. He didn't die of it, but degenerated into Vice" ◊ .Nietzsche.◊

◊ Orgasmic and Graphic Armageddon of Human Flesh.
◊ Obscure Thoughts laid down by Strange Enlightners.
◊ Taboo Themes approached in a Sensuous and aesthetic manner, including Ancient and Pagan Pornography.
◊ NecroRealism is the Woman's Deification, the Return to Sacred Eroticism. It's the Akavistic Memory that recalls these tangled bodies, burning in the Blasphemous bitter flavour... annihilating Death.
◊ The image may be crude and sincere when self-explanatory. Whether done in photographic montage or with surgical brushes, NecroRealism works on offered flesh or creates curved bodies with Biblical breasts...
◊ A mouvement where the Extreme and the Forbidden meet and converge towards a unique end... the Primal Scream's transfiguration Through Art: Clamor Primus.

Necroincubators: G. Grää
To Gayrard

Post-Mortem: P.A.L. (Pornographic Aftermath) Laboratories and Indecent Exposure are mediums contributing to this Apocalyptic Arts development and also asso

◊ A N N O M C M X C V ◊

P.A.L.
69, Rue d'Avron
75020 PARIS
FRANCE

Indecent Exposure
8 CHEMIN DE LA BOURIOTTE
81 430 VILLEFRANCHE D'ALE
FRANCE

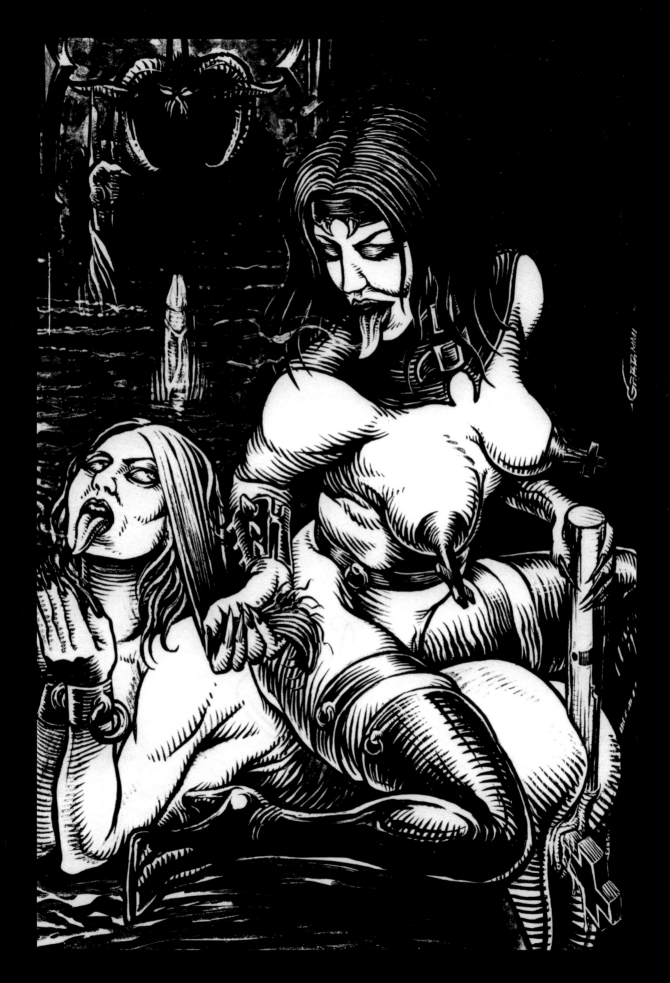

DENIS GRRR Apocryphorgy

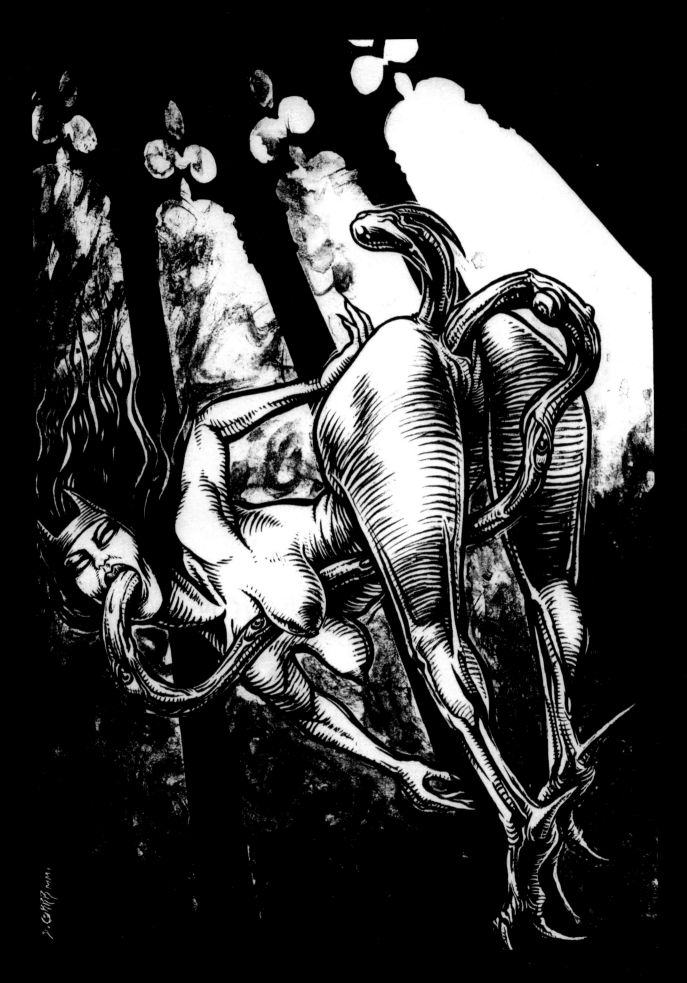

DENIS GRRR **Apocryphorgy**

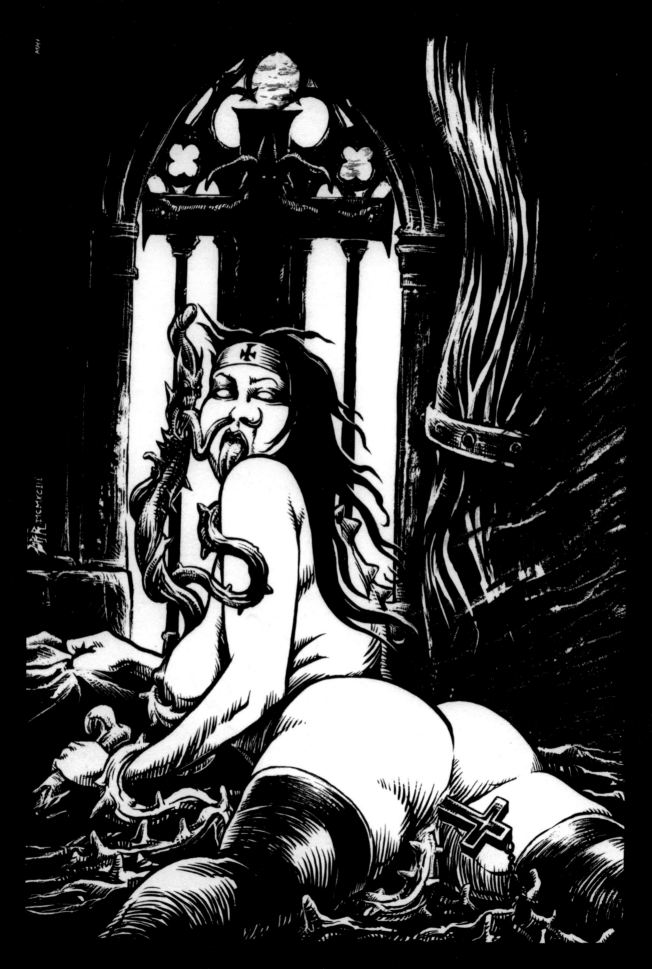

DENIS GRRR **Apocryphorgy**

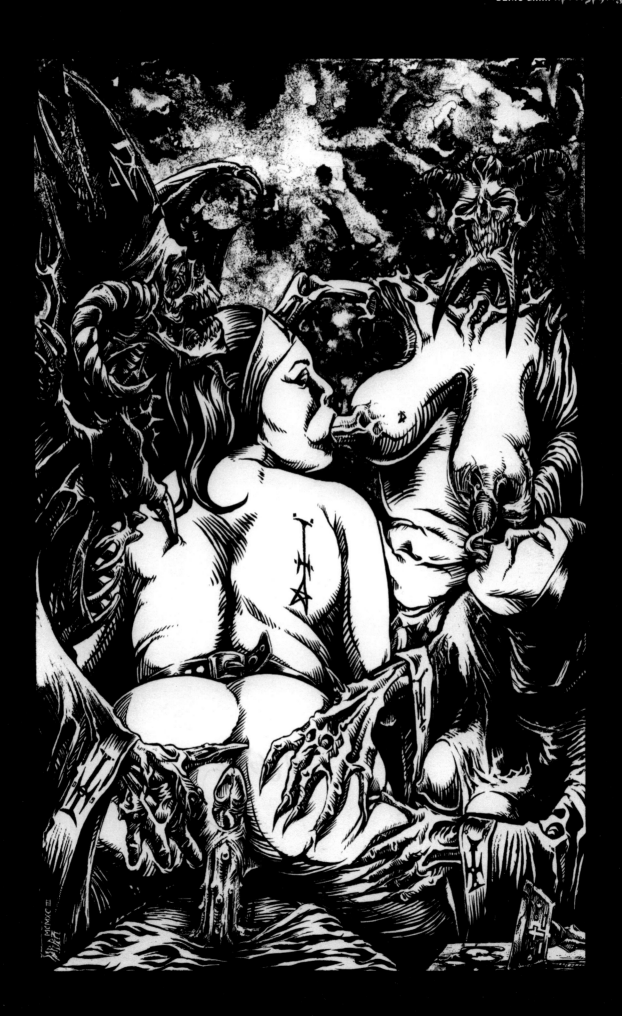

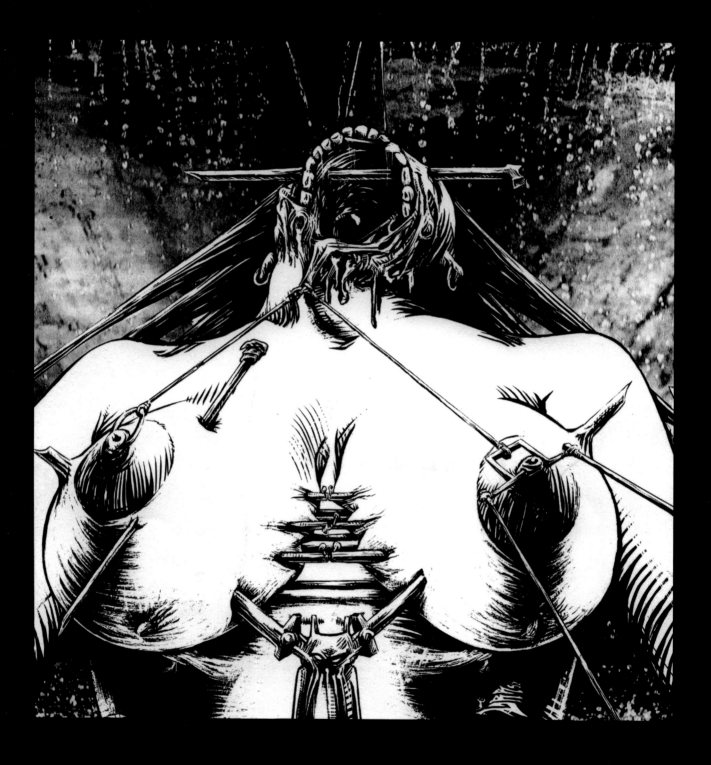

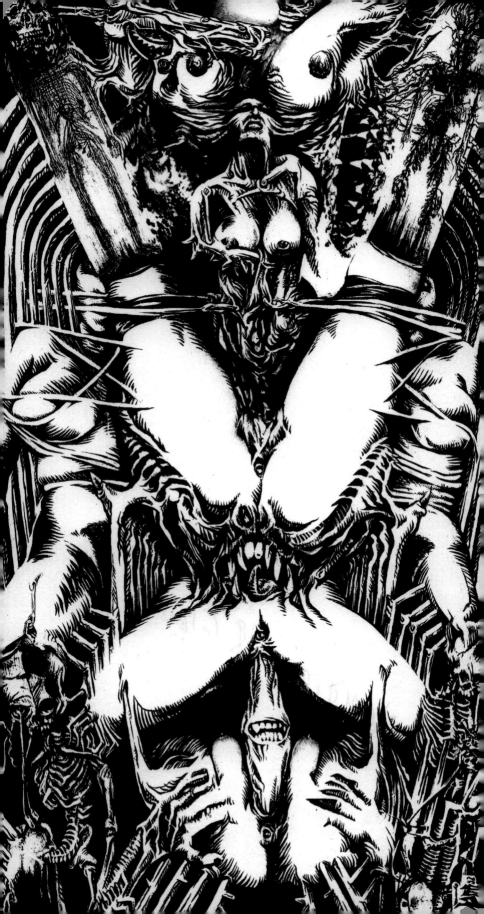

DENIS GRRR **Apocryphorgy**

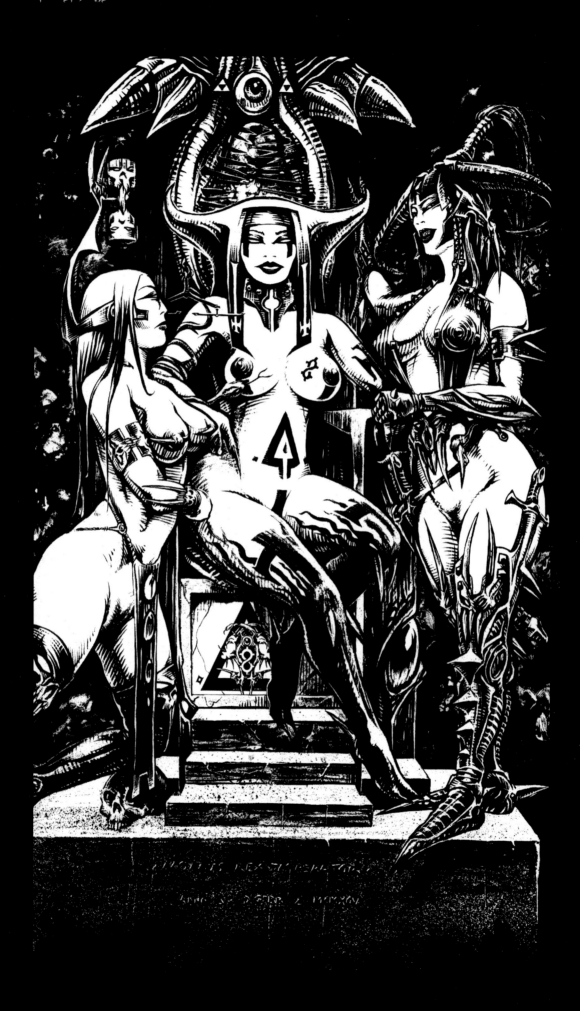

DENIS GRRR **Apocryphorgy**

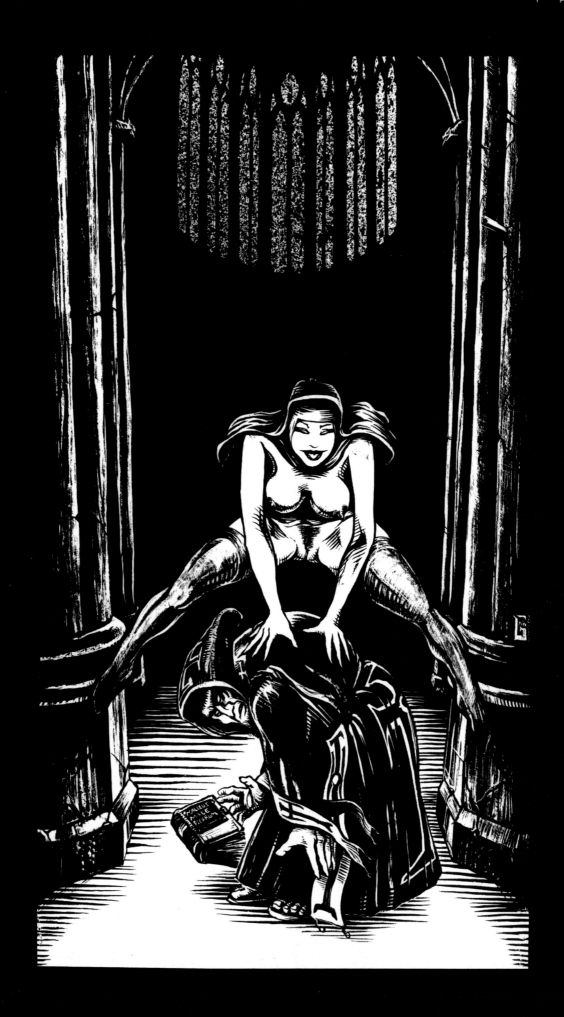

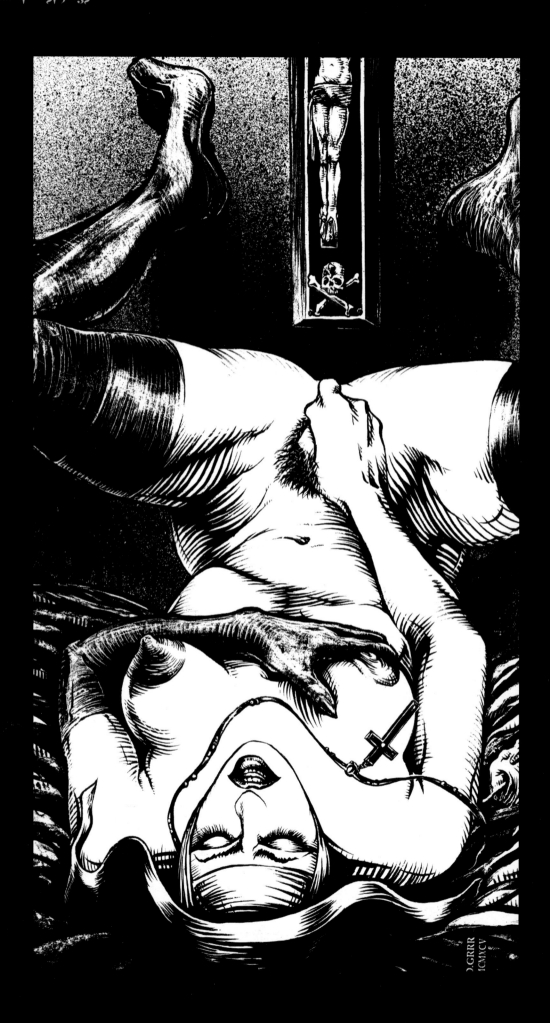

DENIS GRRR **Apocryphorgy**

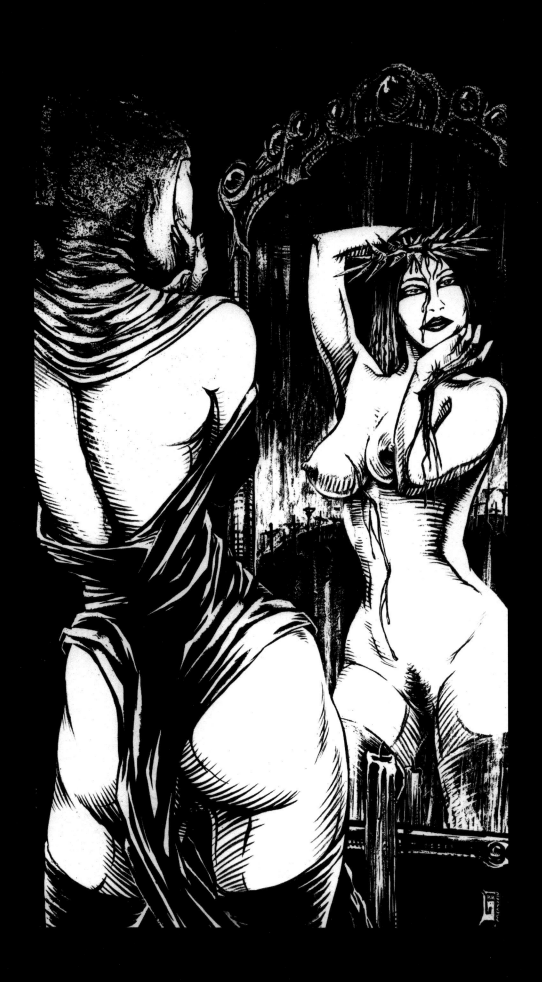

DENIS GRRR **Apocryphorgy**

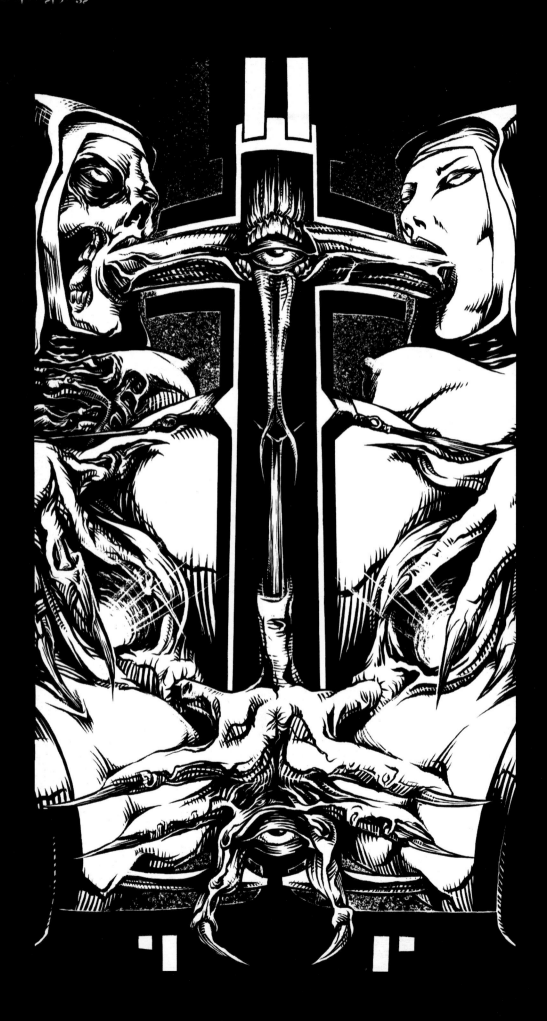

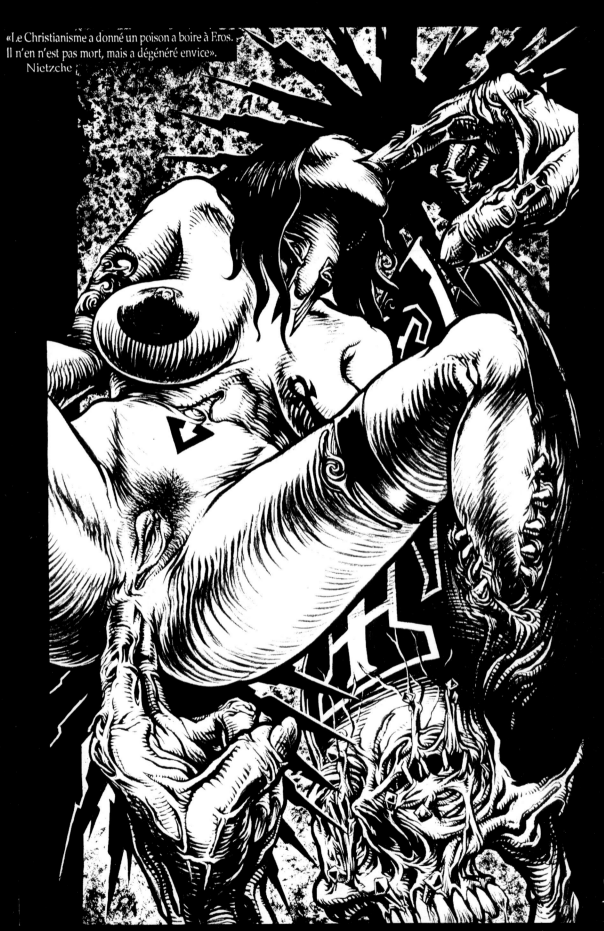

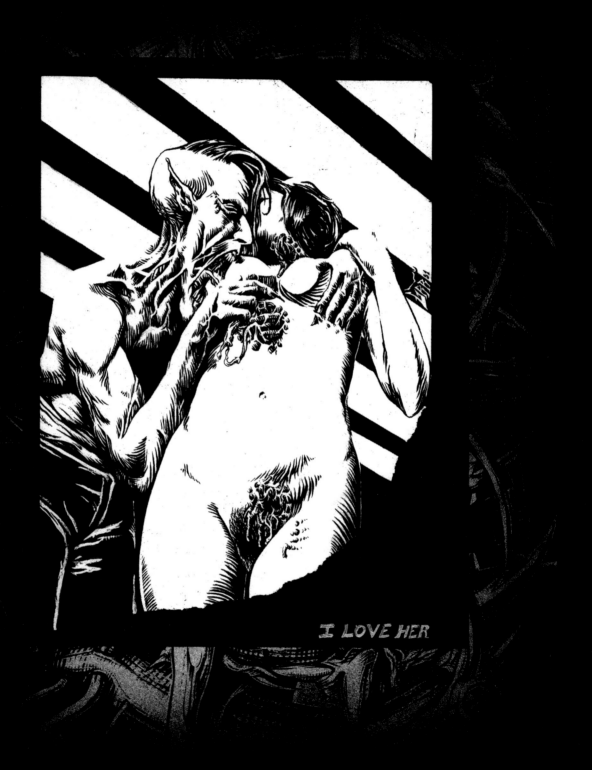

DENIS GRRR **Apocryphorgy**

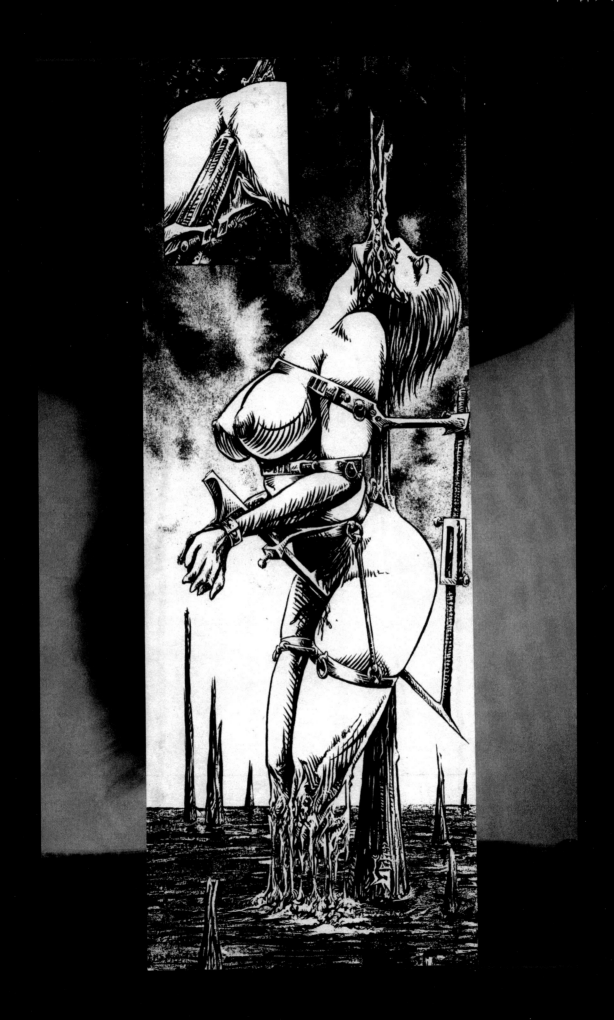

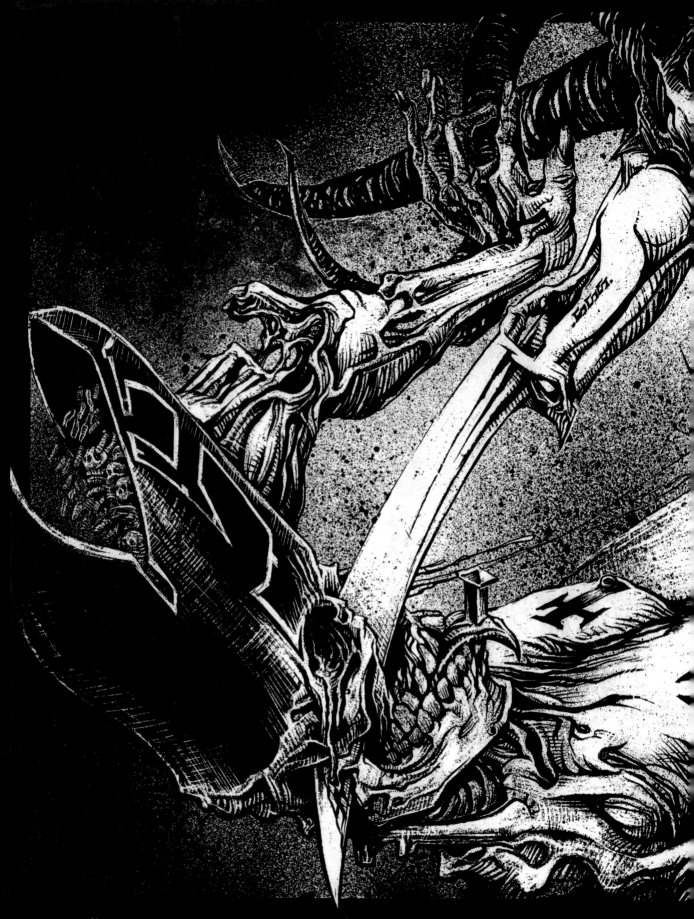

Voici venu le temps de la Parousie; le temps de la Haine. Le temps du Carnage et du Sang versé. Le temps de Délivrance. Par le Feu de la Géhenne, je pourfendrai l'Impie et le Pourceau; j'éventrerai le Tyran, que son sang impur emplisse les eaux des Océans. Je veux vous entendre hurler, quand les Flammes brûleront vos âmes putrides et nauséabondes; que vos chairs se tordent, que vos bouches se convulsent. Et quand à genoux, pitoyables et souffrants, vous implorerez le Pardon, je redoublerai de violence; et trancherai vos têtes. Je jetterai à terre votre Idole Crucifiée; et j'appâterai mille pieux pour y empaler les Prêtres et les Seigneurs de la Terre. (...)

L'EVANGILE APOCRYPHE - Sacripanus, Livre III.

Quand les nuées de cendres, de sang et de poussière assombriront le Monde, et que les glaces des pôles se fractureront; alors sera délivré l'ANDROGYNE PRIMORDIAL, PRISTINUS ANDROGYNUS. Et IL se hissera sur le plus haut sommet des glaciers, et IL contemplera le Désastre et le Chaos de l'HUMANITE II; et IL saura que la DEITE-MERE est à l'agonie. Alors dans Ses yeux brûleront les Flammes de la Vengeance, et IL viens mettre un terme à l'etablissement du Royaume de Désolation. MAERORIS REGNUM.

L'EVANGILE APOCRYPHE - Apocalypsis.

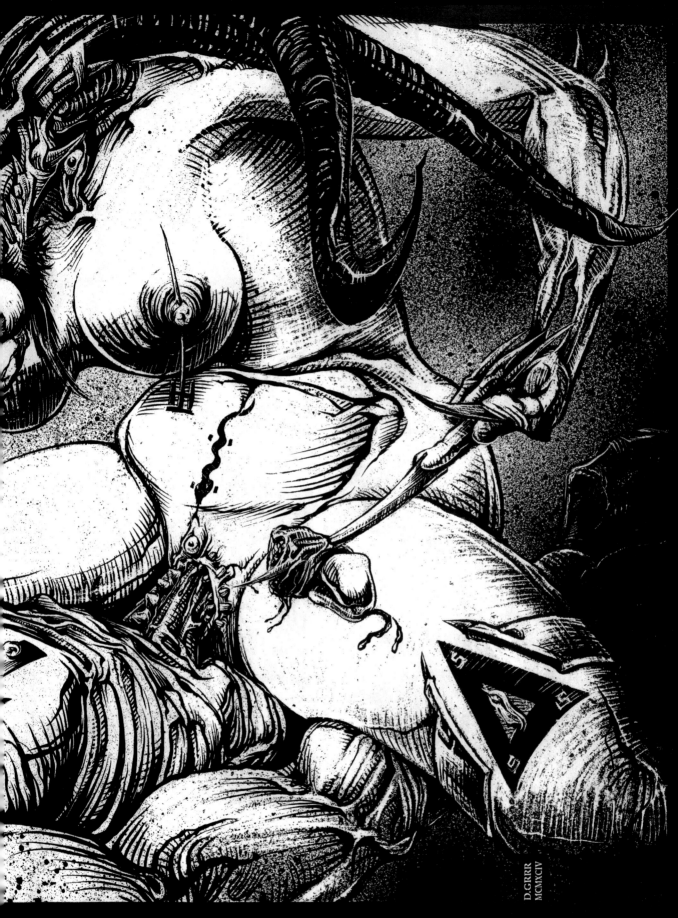

Now has come the time of the second coming; the time of Hatred. The time of Slaughter and Bloodshed. The time of Deliverance. By the Fire of Gehenna, I will slay the Infamous and the Swine; I will disembowel the Tyrant, let his tainted blood fill the waters of the Oceans. I want to hear thou howl, when the Flames will burn thy putrid and nauseating souls; let thy flesh writhe, let thy mouths convulse. And when on thy knees, pitiable and suffering, thou will beseech Mercy, I will redouble violence; and I will cut off thy heads. I will throw to the ground thine Consecrated Idols; and I will whet thousand stakes to impale on them the Priests and Lords of the earth. (...)

APOCRYPHAL GOSPEL - Sacrificium, Book III.

When the clouds of ashes, of blood and of dust, will darken the World, and when the poles' ice will fracture; then will be rescued, prisonner of the Glass Coffin, the PRIMEVAL ANDROGYNE. PRISTINUS ANDROGYNUS. And HE will hoist himself to the highest summit of the glaciers, and HE will contemplate the Disaster and the Chaos of HUMANITY II; and HE will know that the MOTHER-DEITY is at her last gasp. Then in His eyes will burn the Flames of Revenge, and HE will strike up the The Song of War. For HE is the ANTECHRIST; and HE comes to put an end to the establishment of the Desolation Kingdom. MAERORIS REGNUM.

APOCRYPHAL GOSPEL - Apocalypsis.

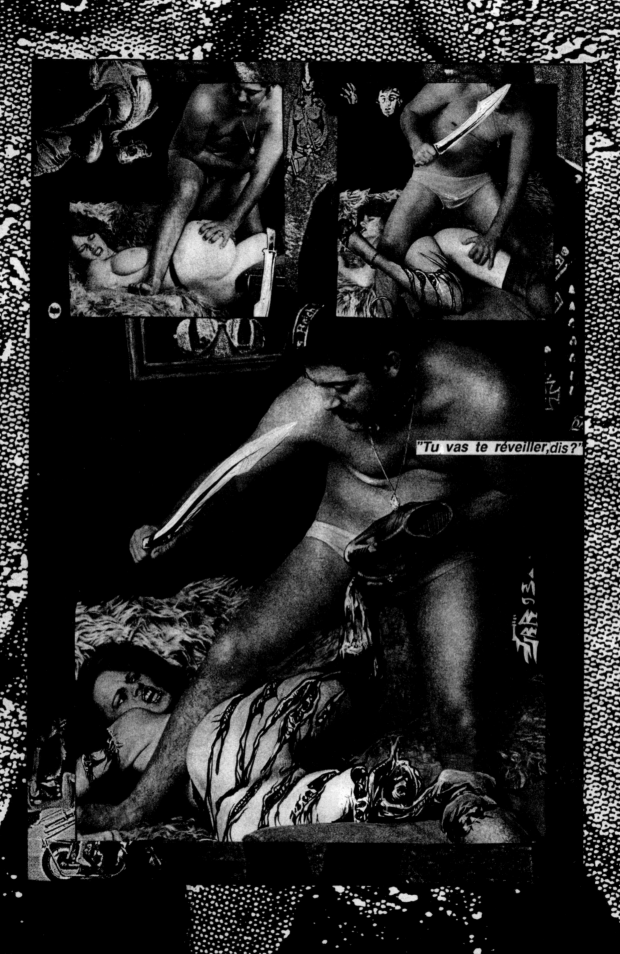

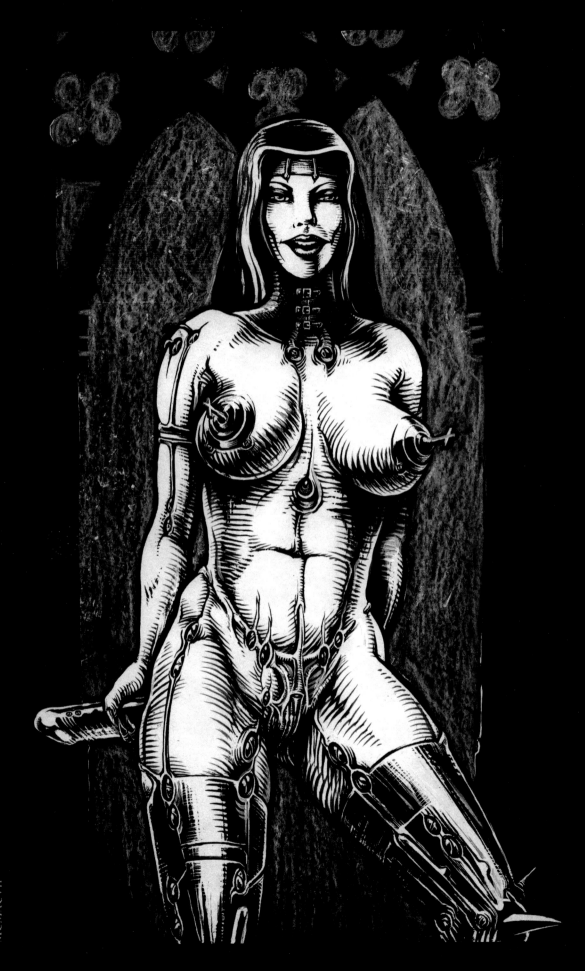

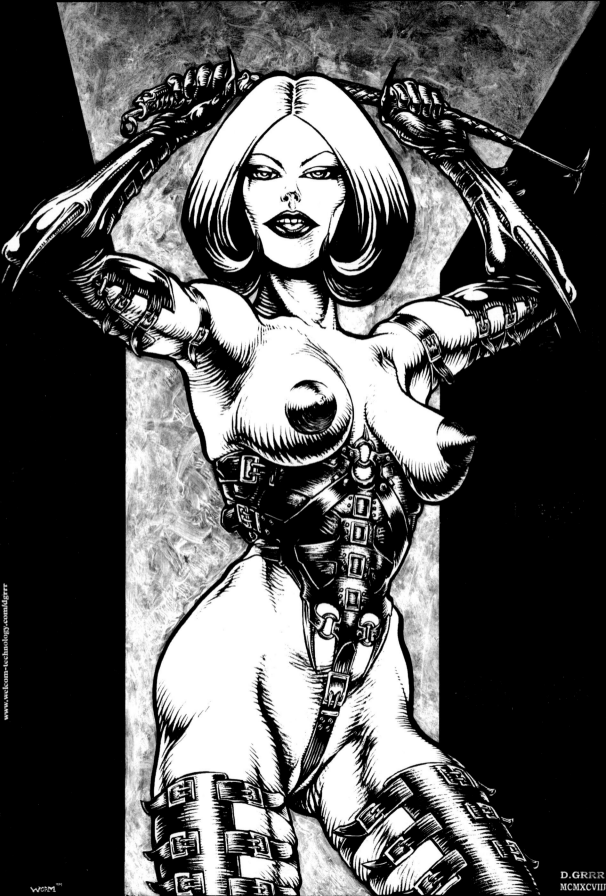

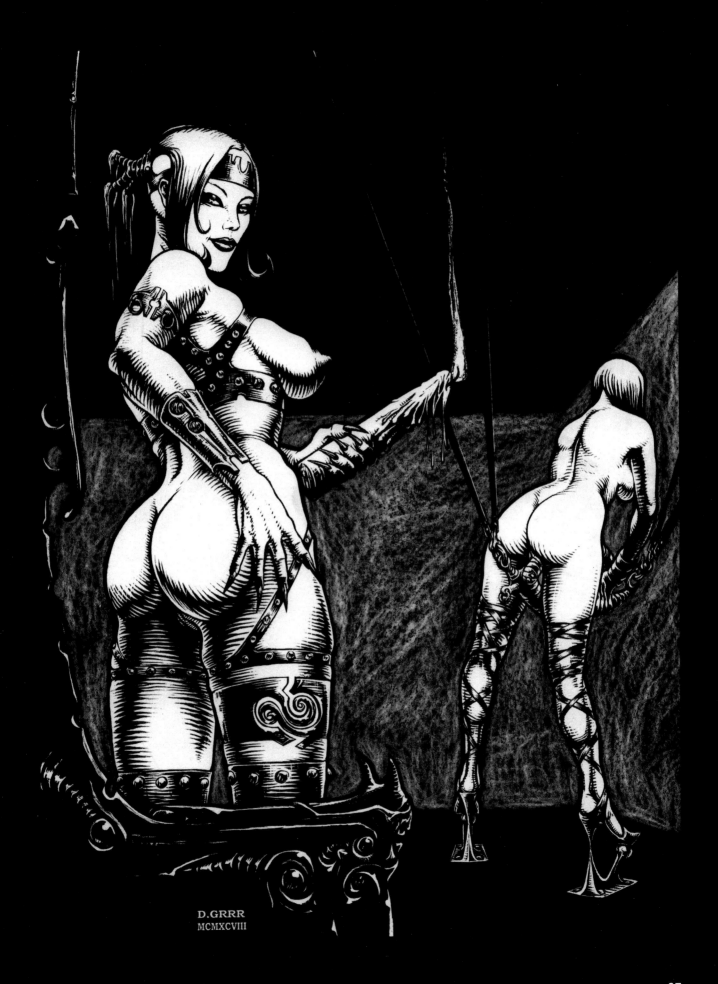

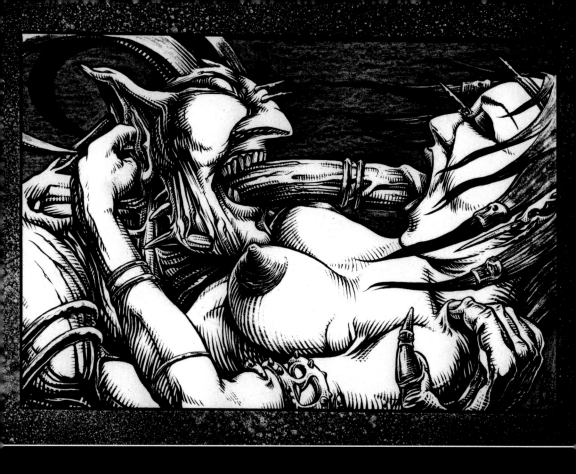
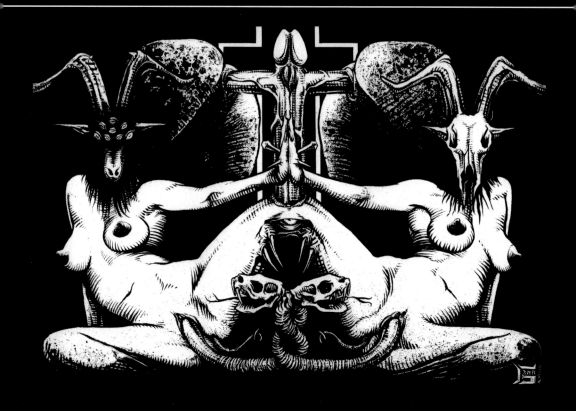

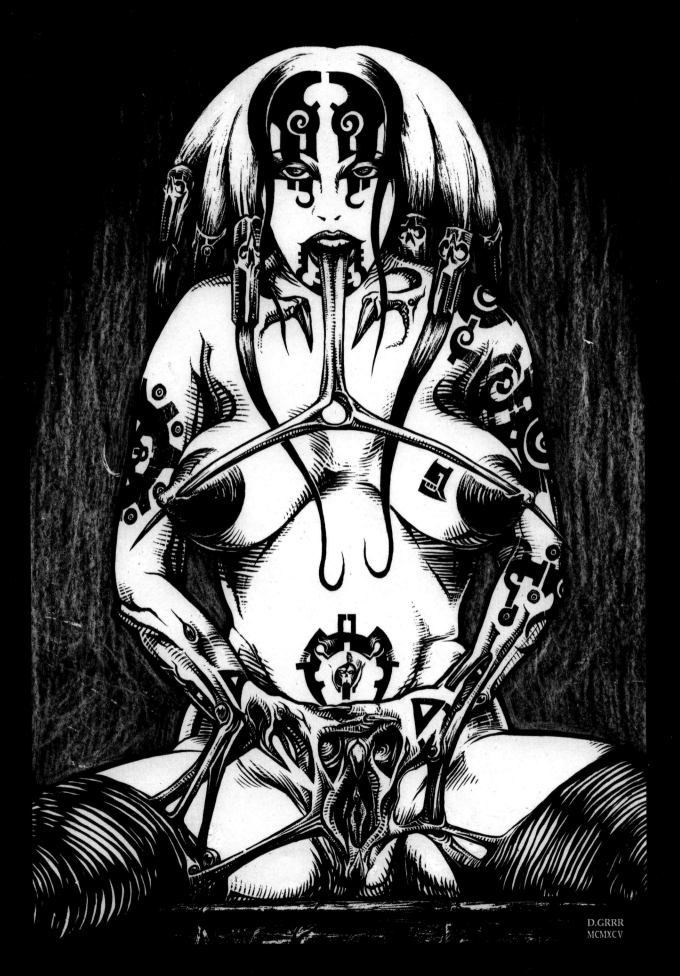

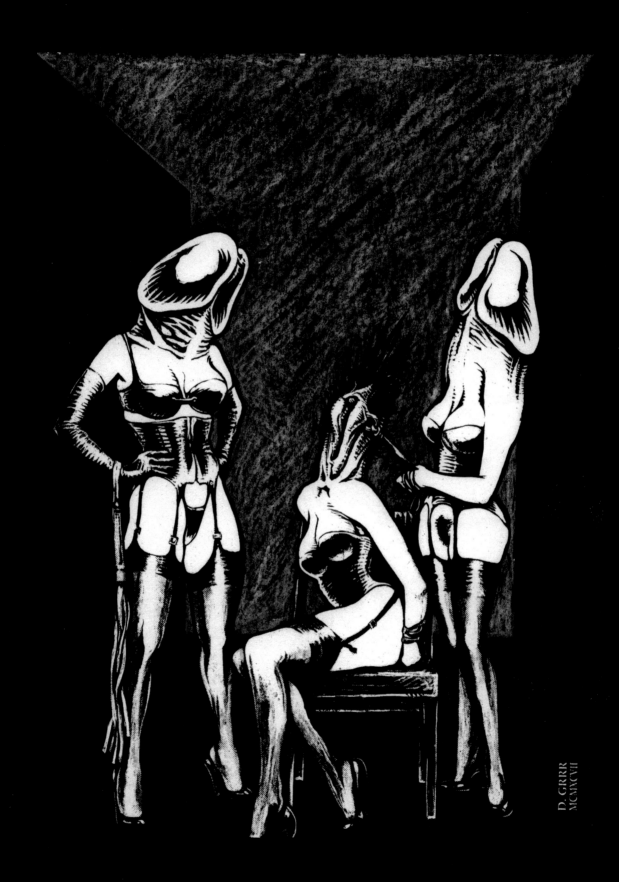

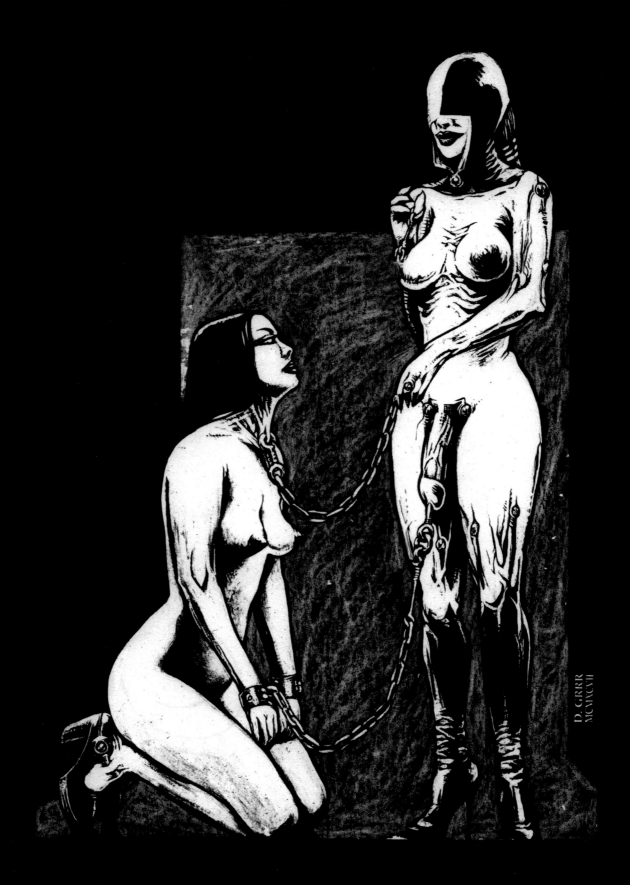

DENIS GRRR Apocryphorgy

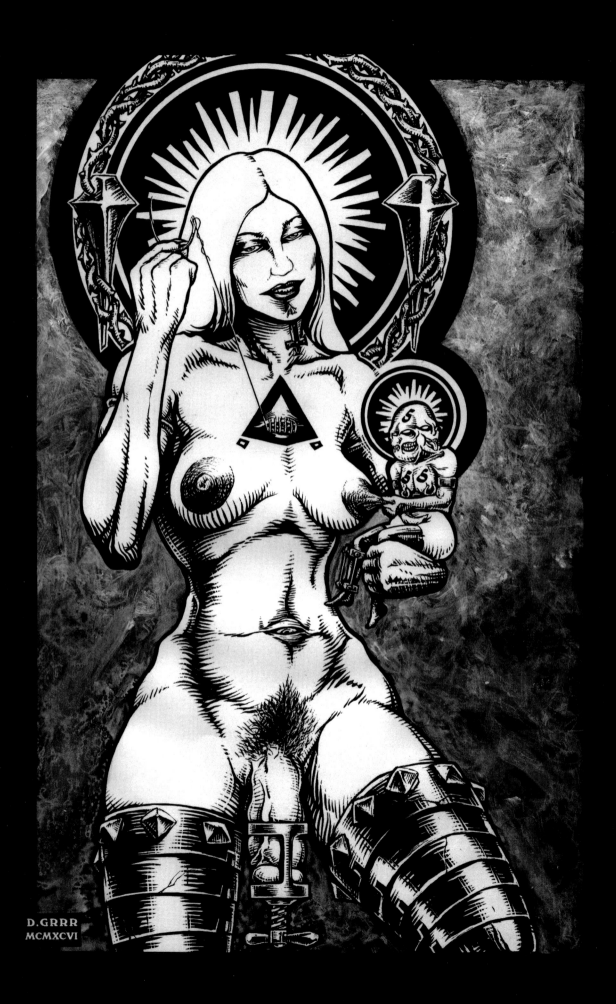

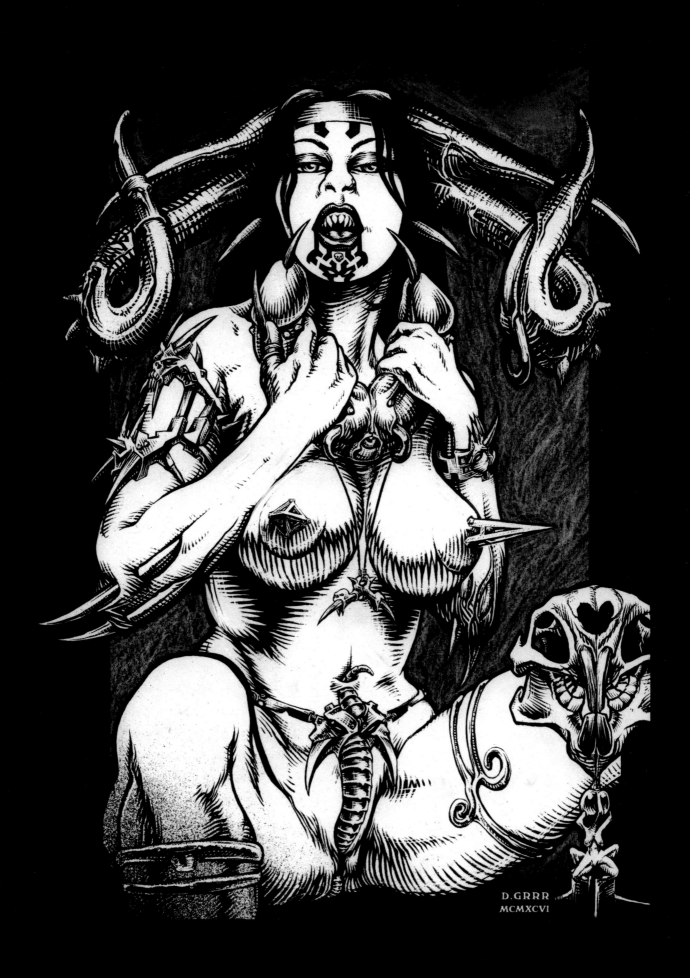

.MON GODE ET MOI.

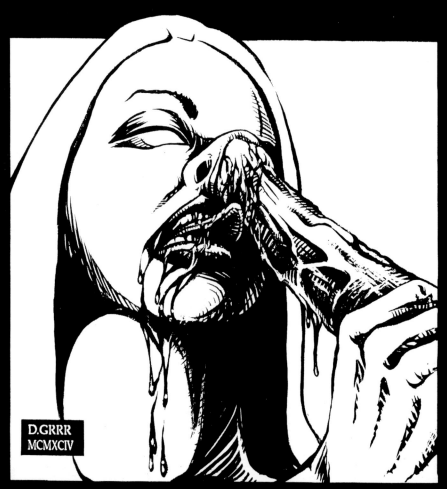

D.GRRR
MCMXCIV

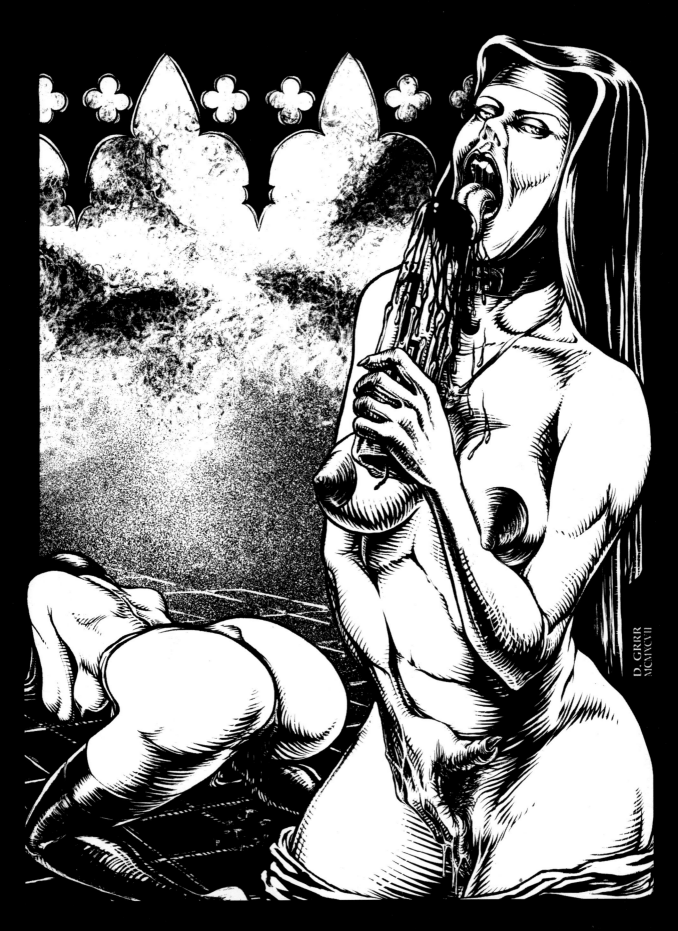

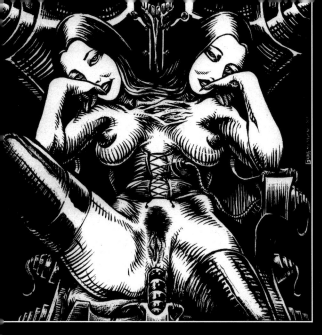
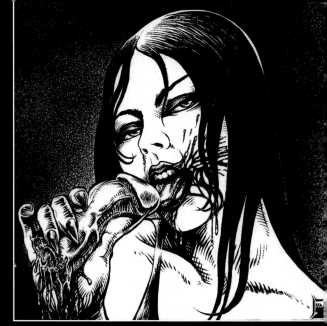
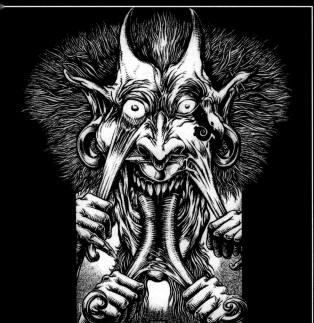
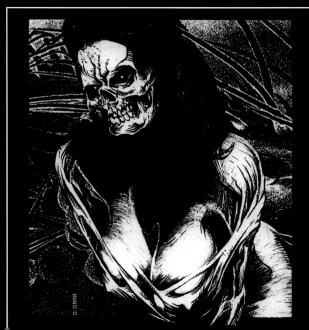

DENIS GRRR **Apocryphorgy**

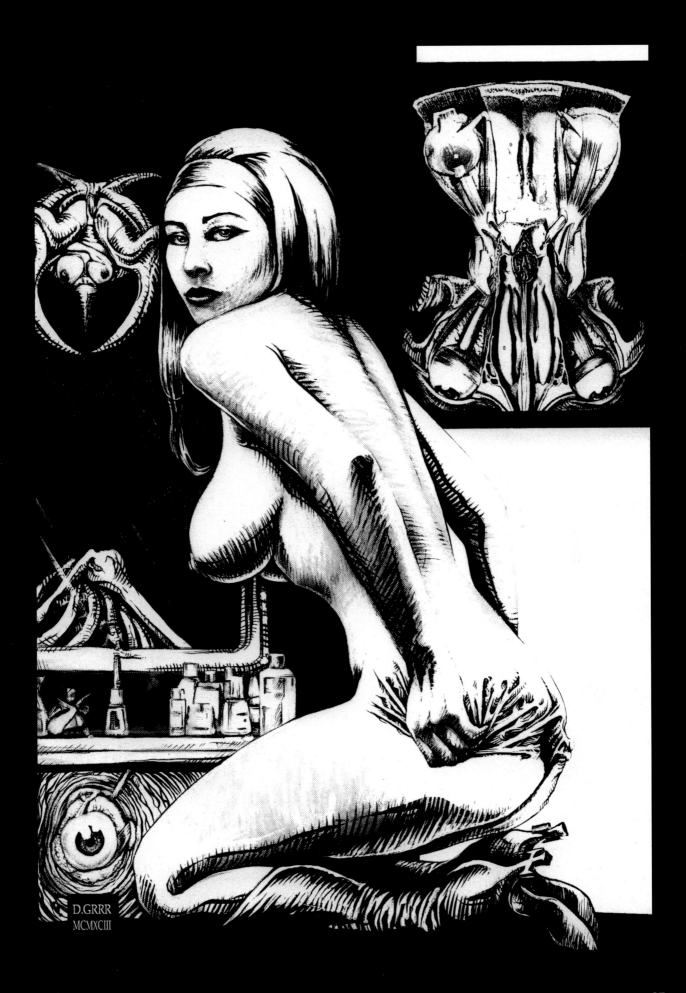

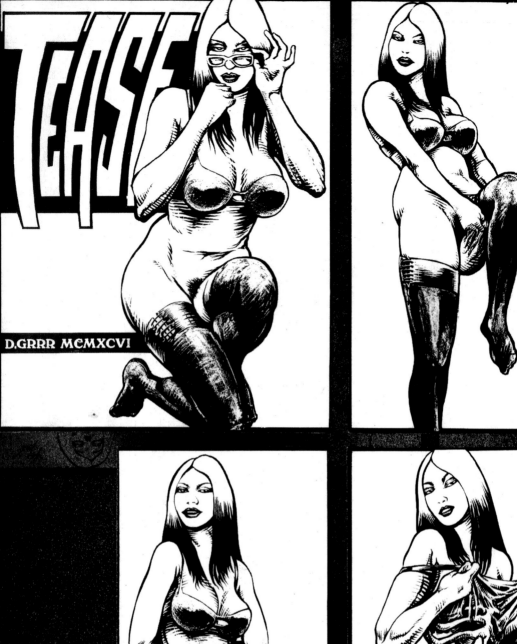
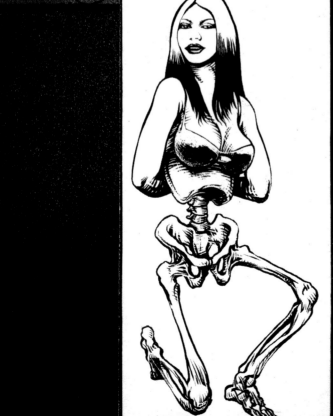
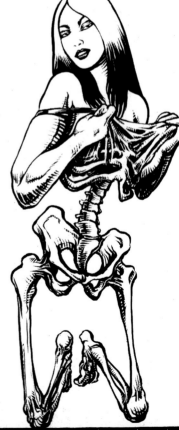

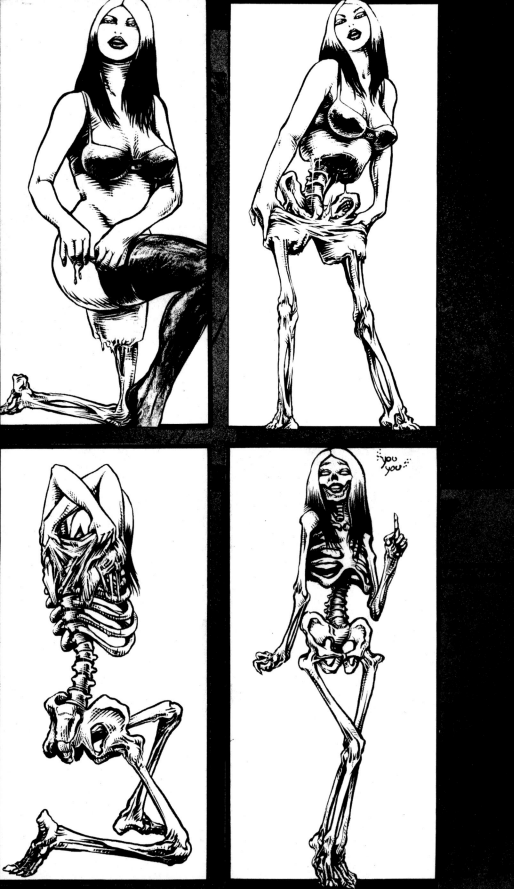

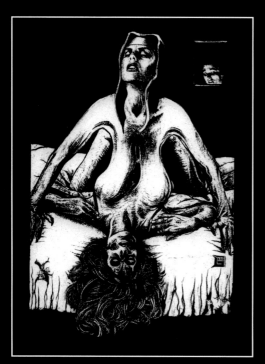
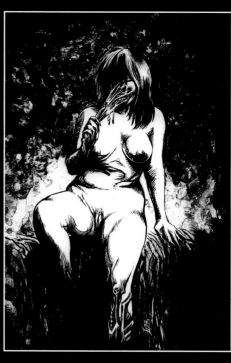
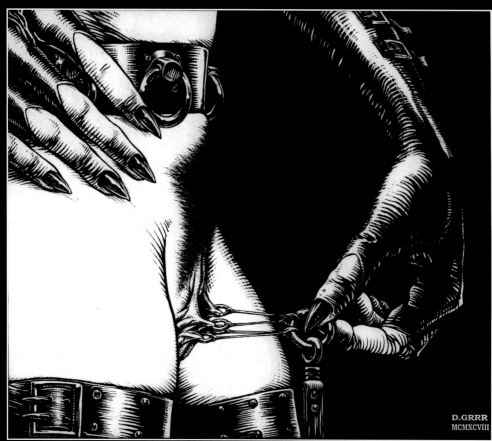

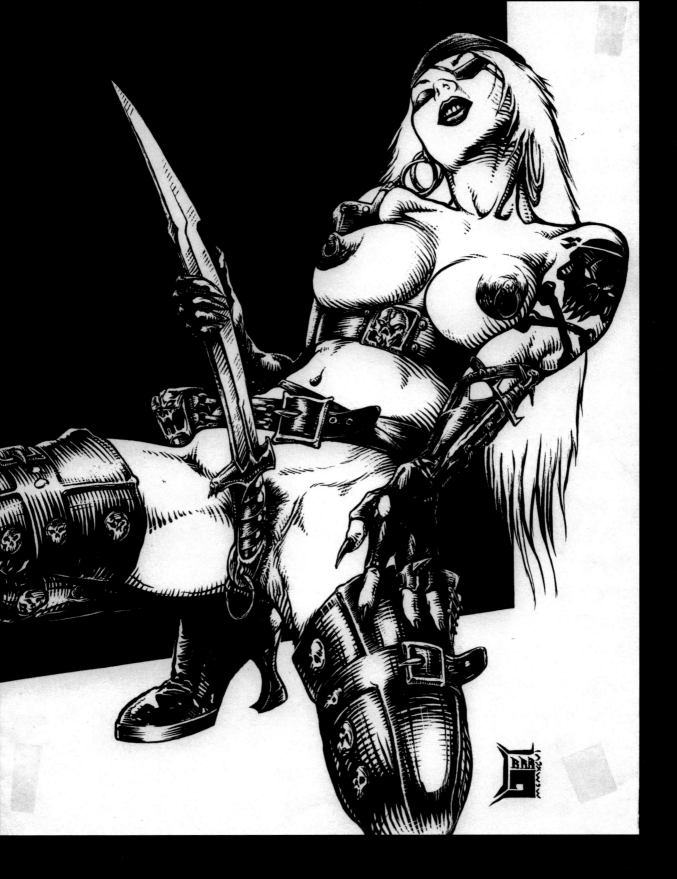

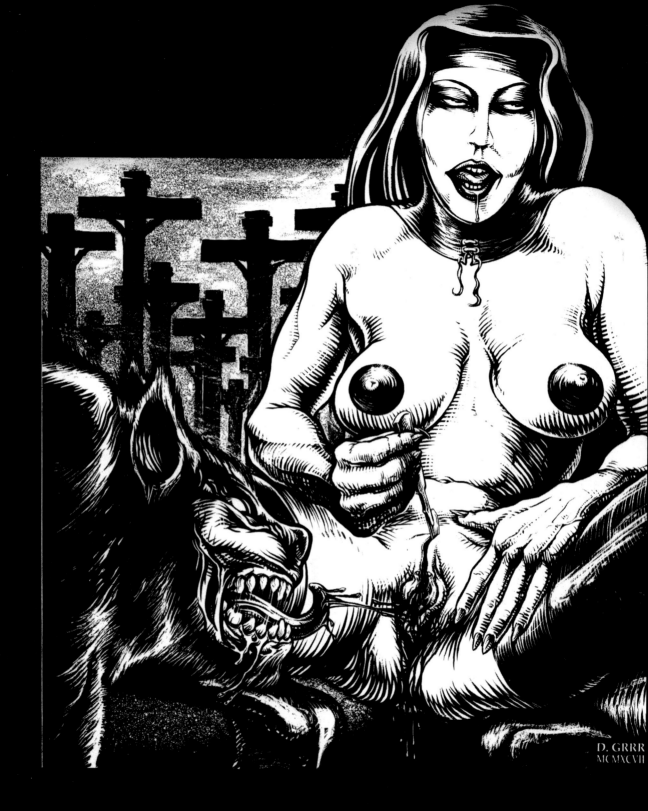

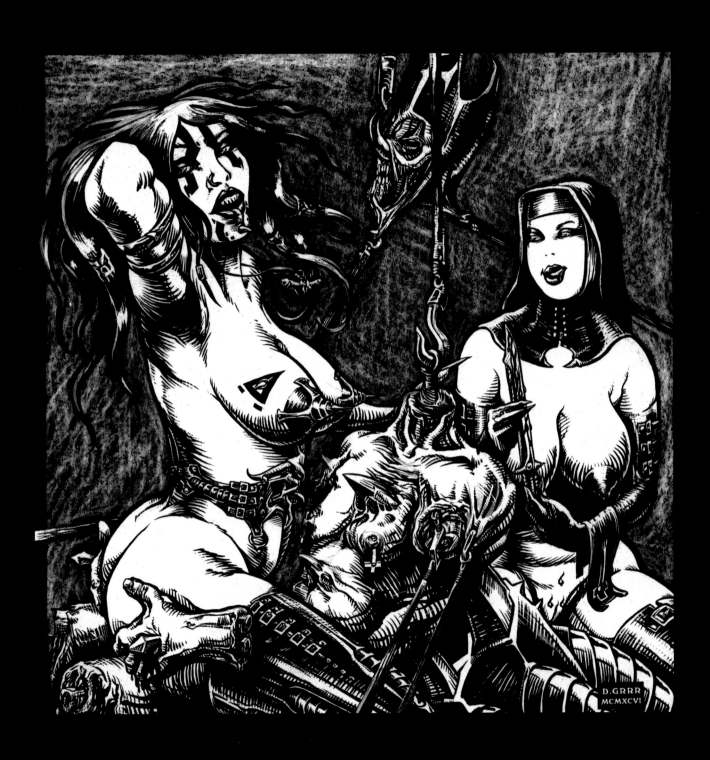

DENIS GRRR *Apocryphorgy*

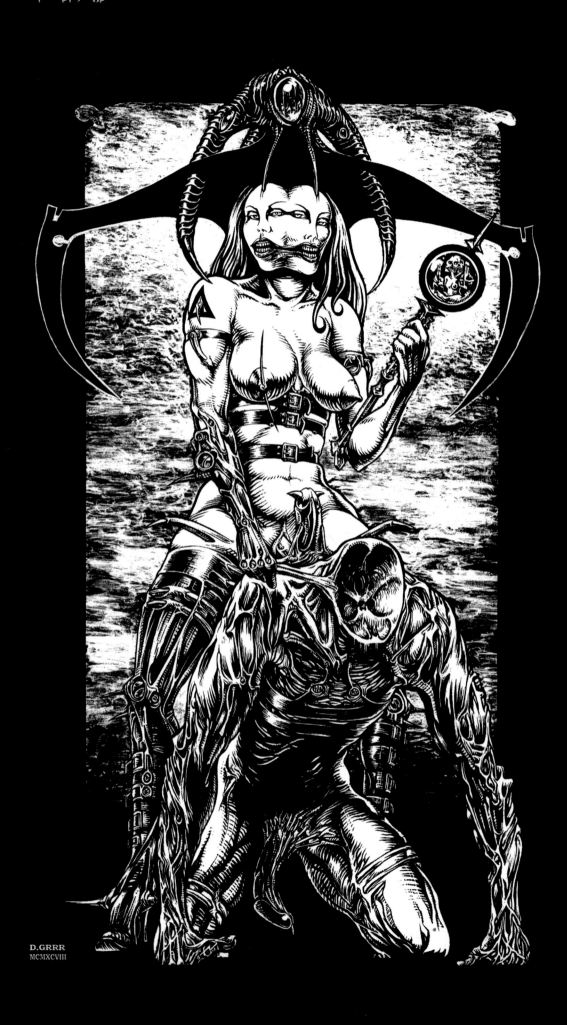

DENIS GRRR **Apocryphorgy**

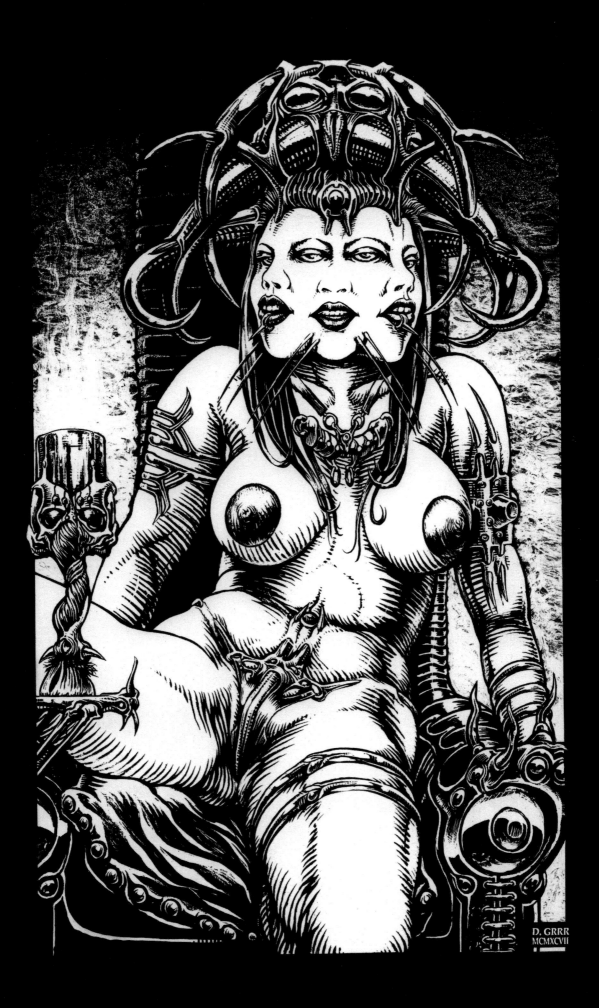

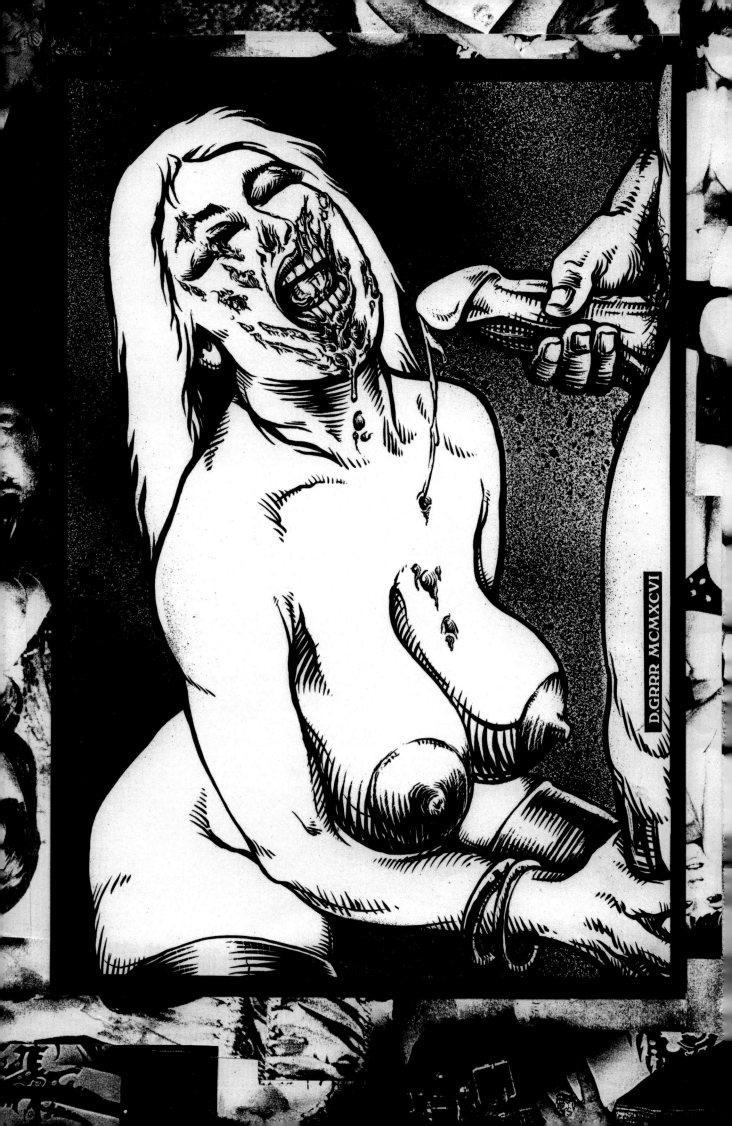

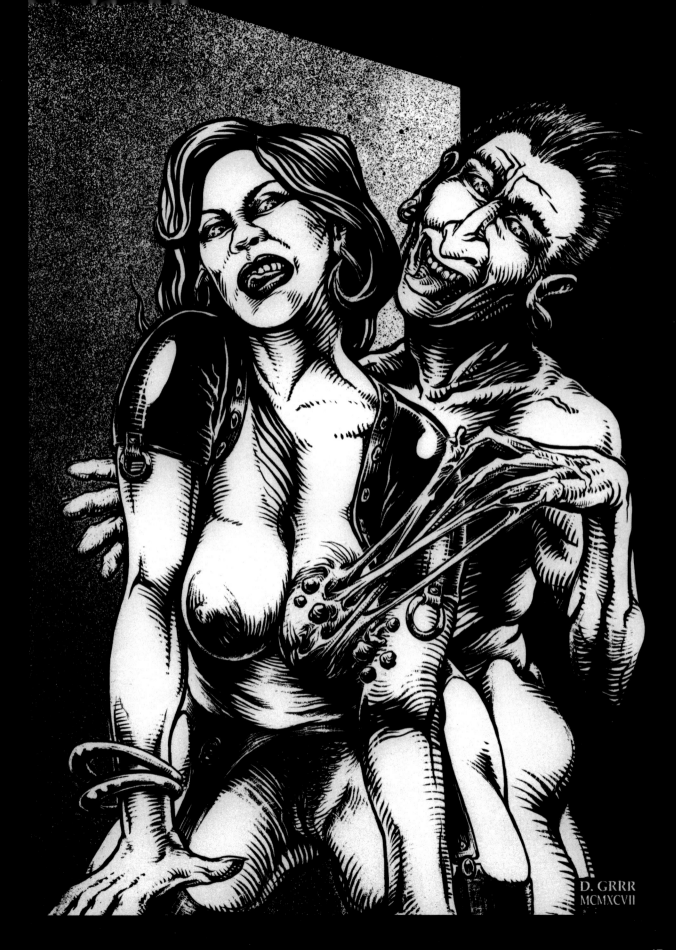

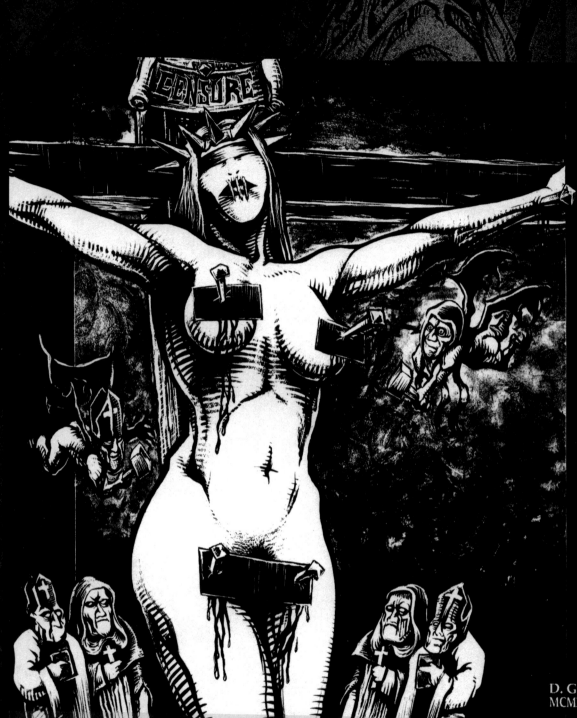

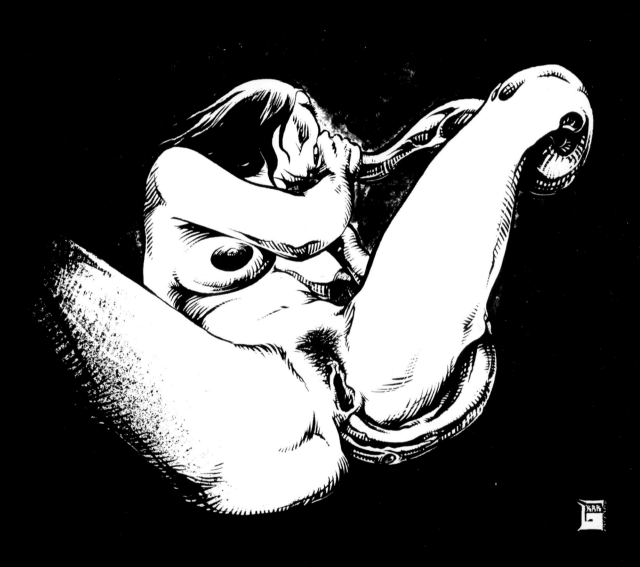

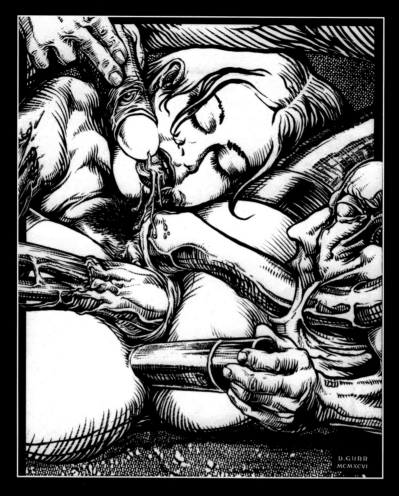
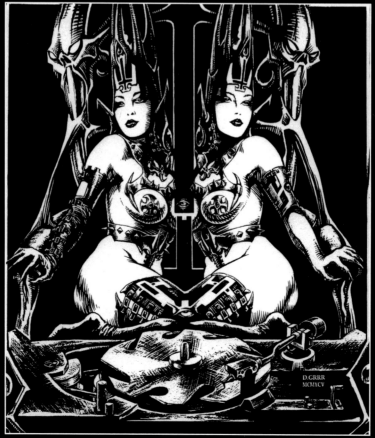

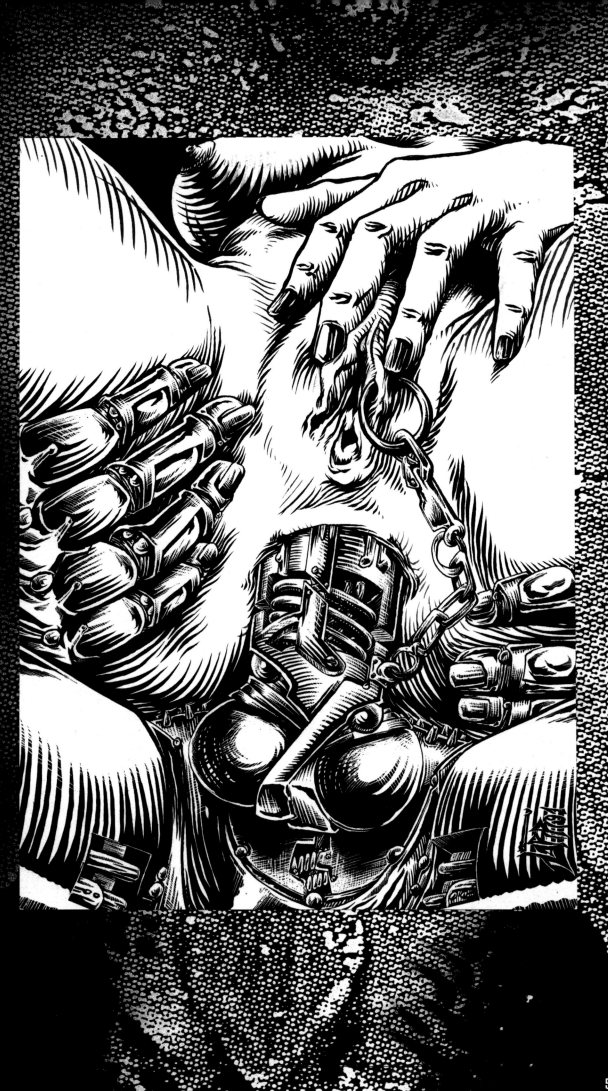

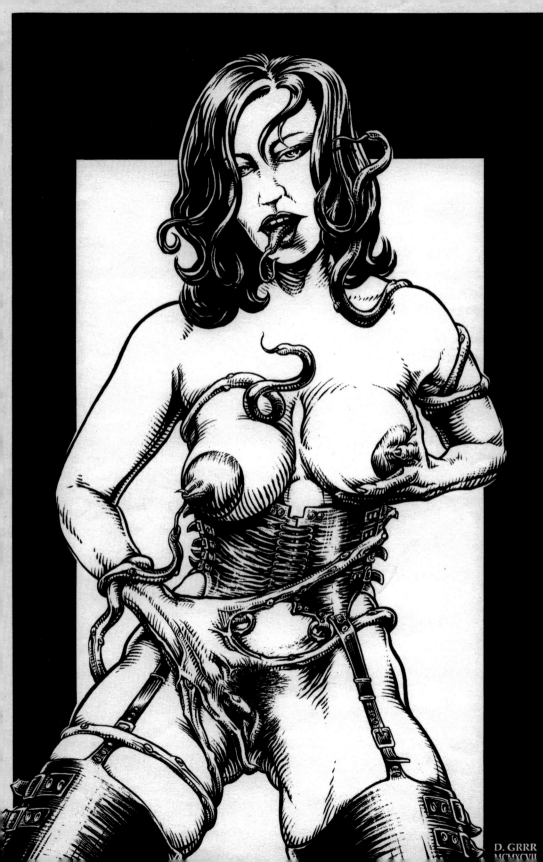

DENIS GRRR **Apocryphorgy**

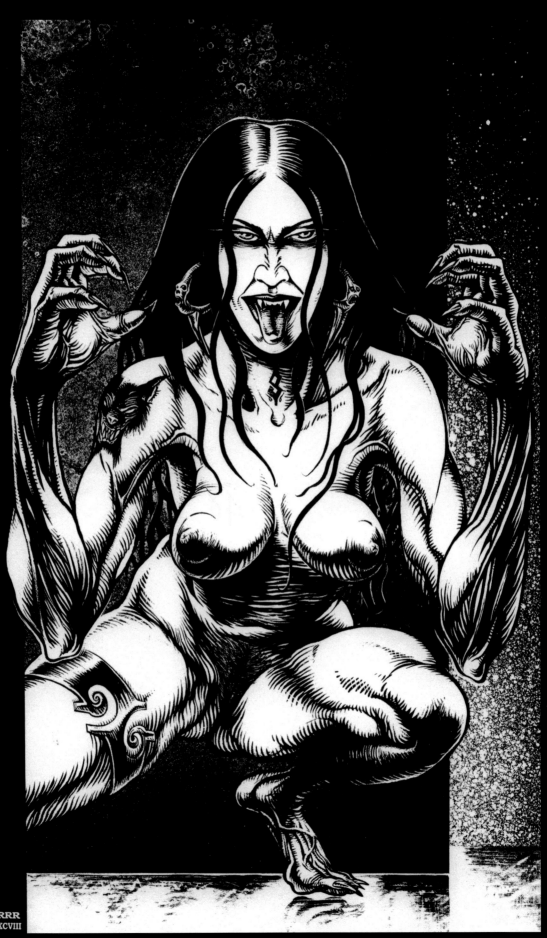

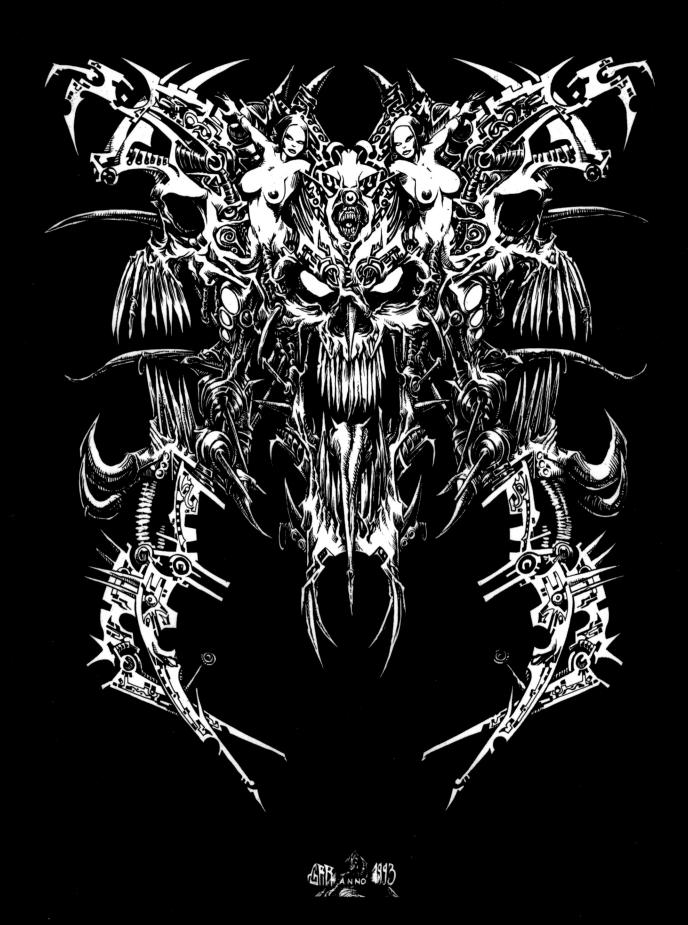

DENIS GRRR *Apocryphorgy*

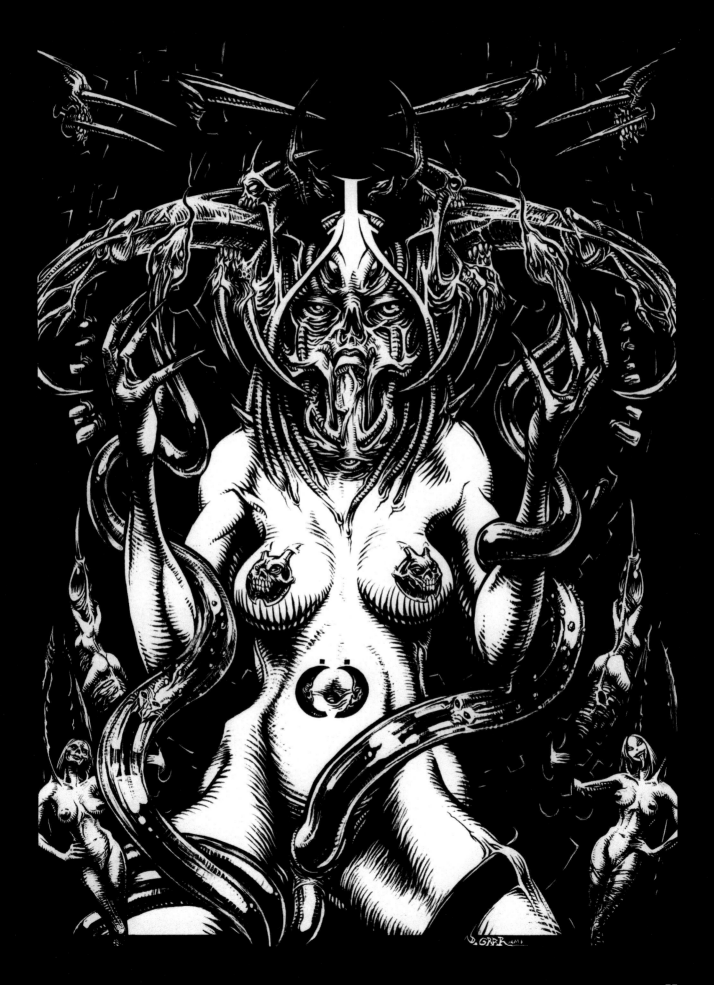

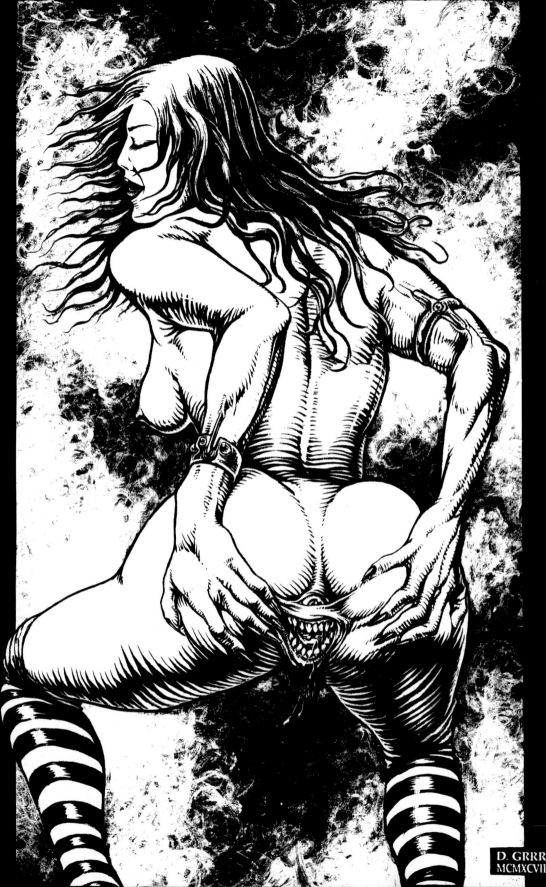

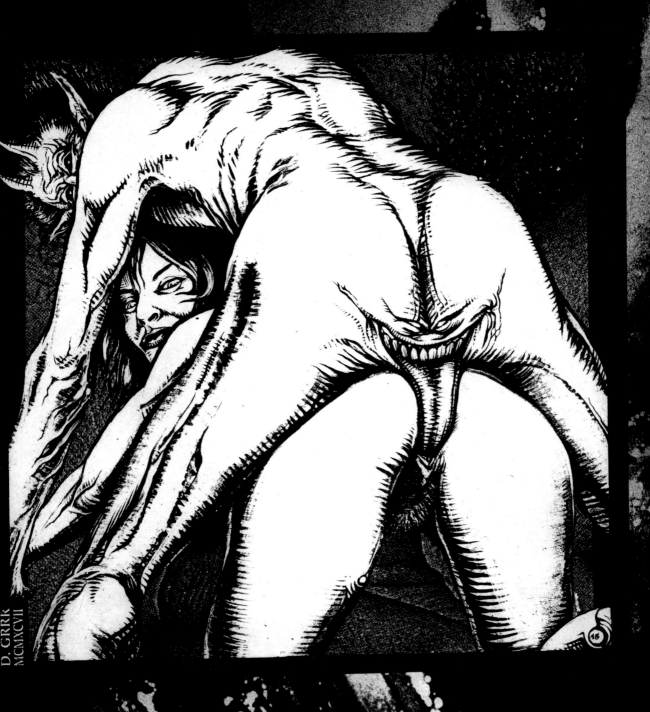

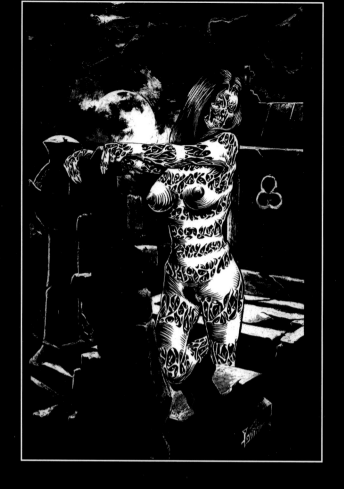
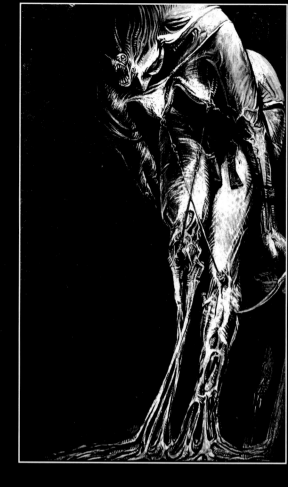
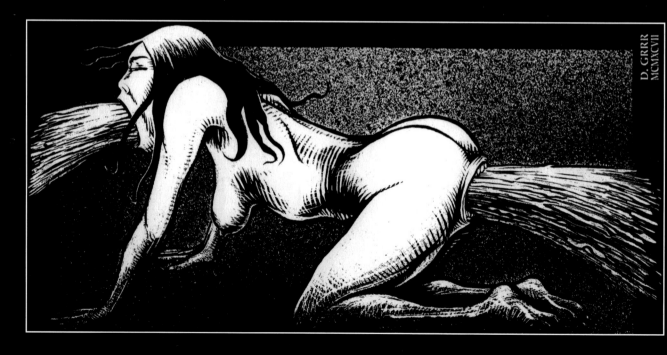

DENIS GRRR **Apocryphorgy**

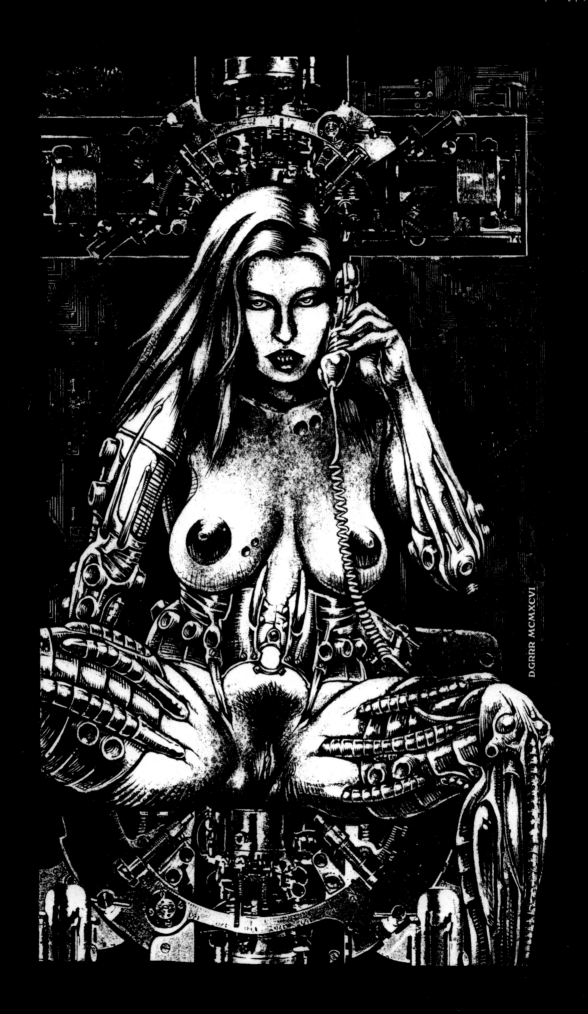

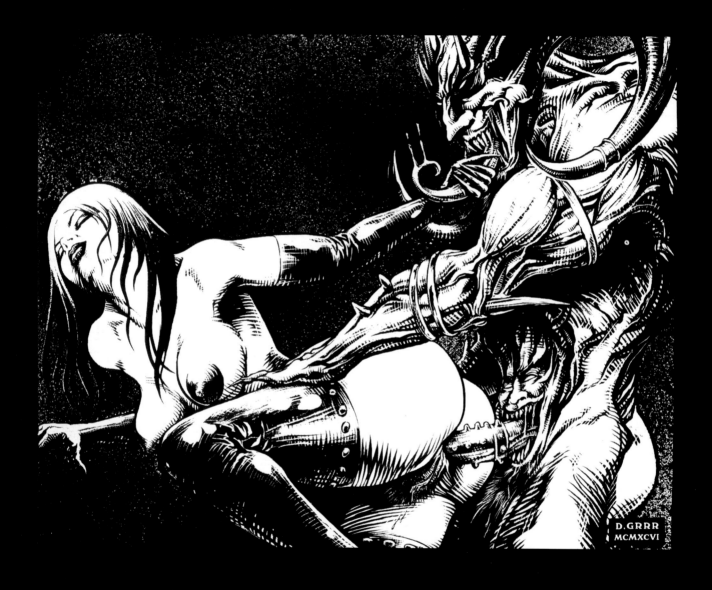

DENIS GRRR **Apocryphorgy**

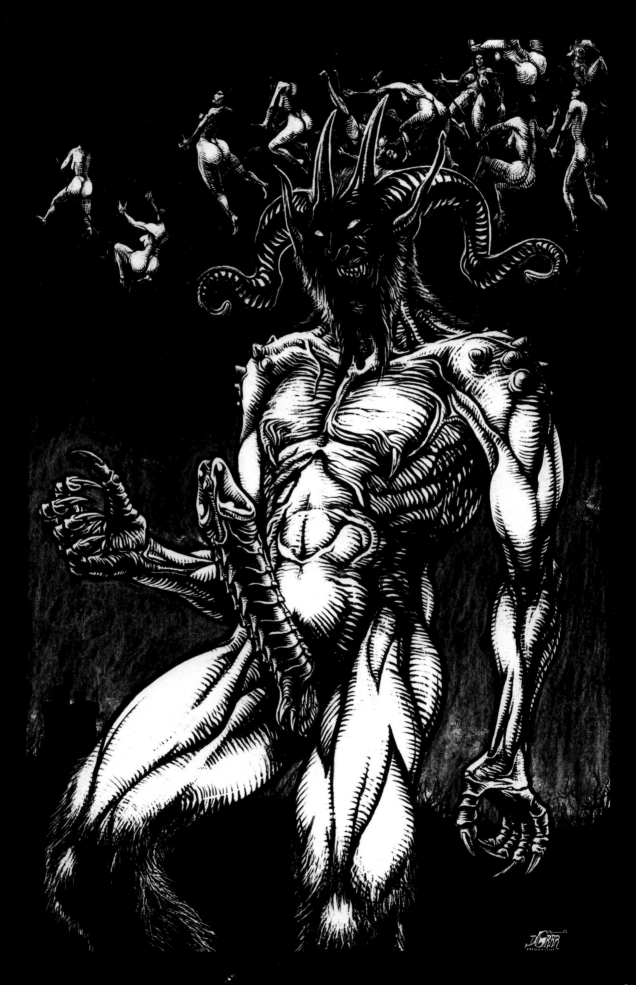

DENIS GRRR **Apocryphorgy**

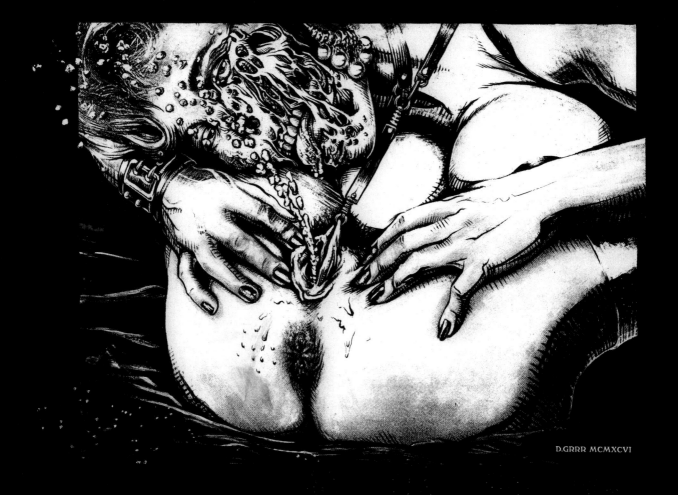

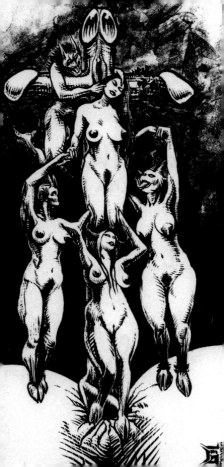

DENIS GRRR **Apocryphorgy**

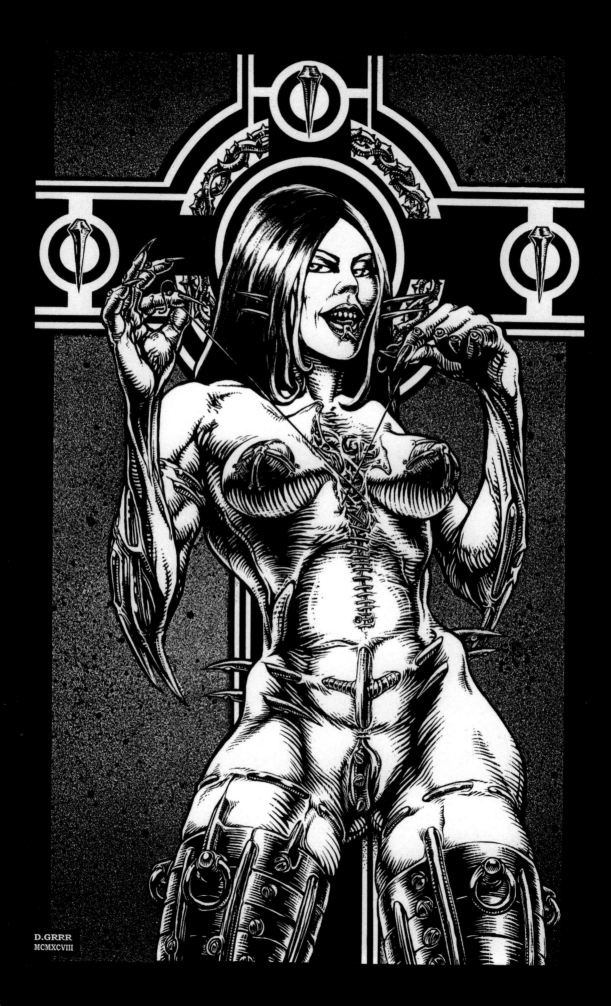

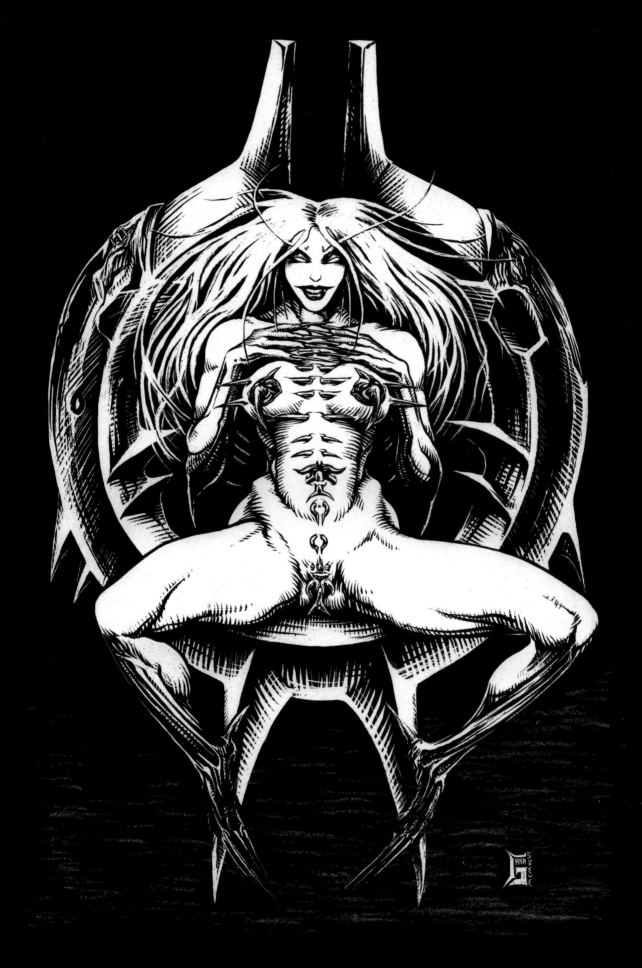

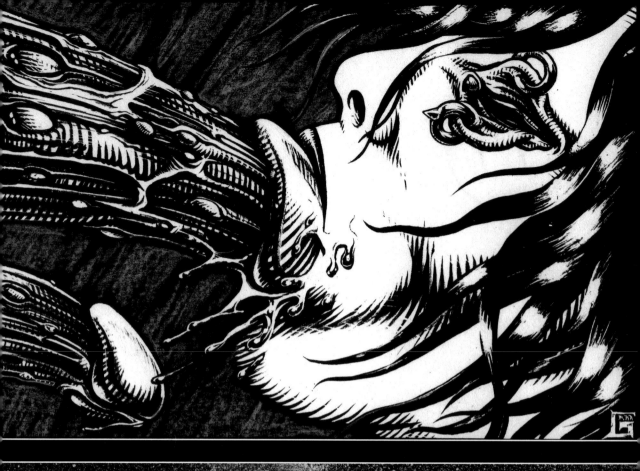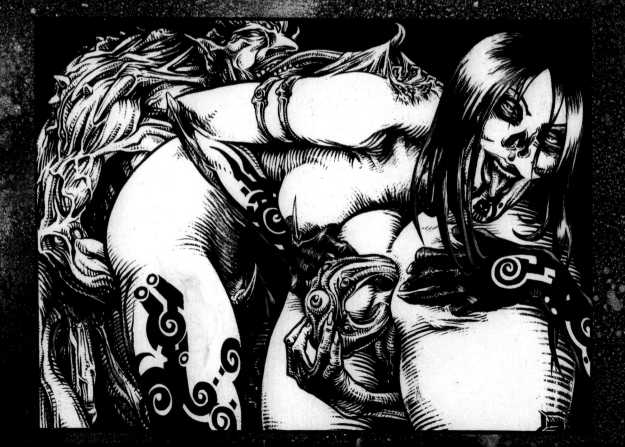

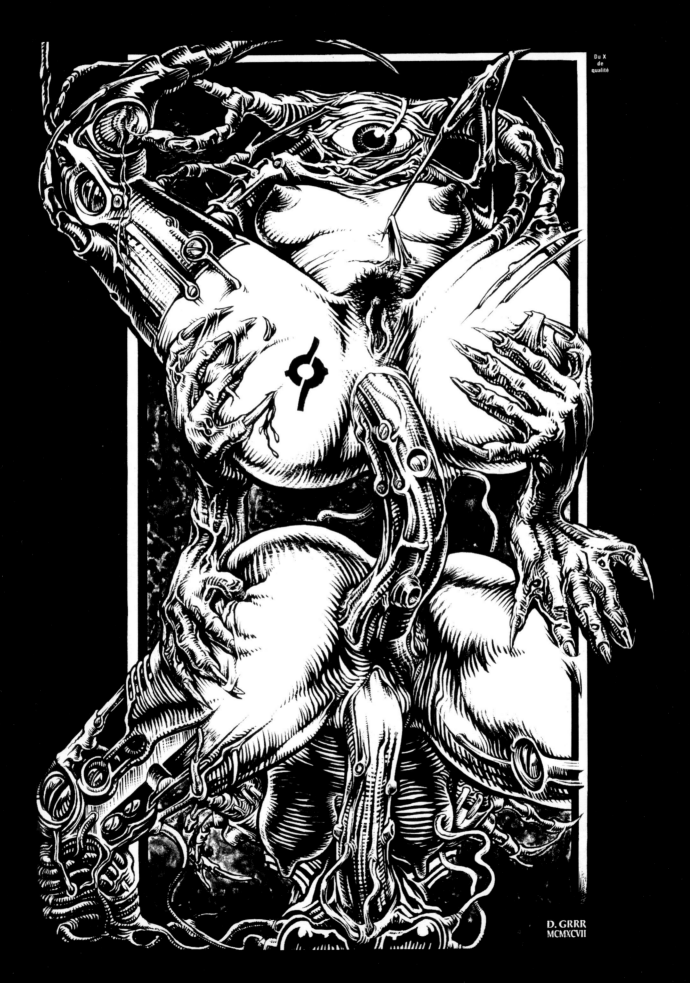

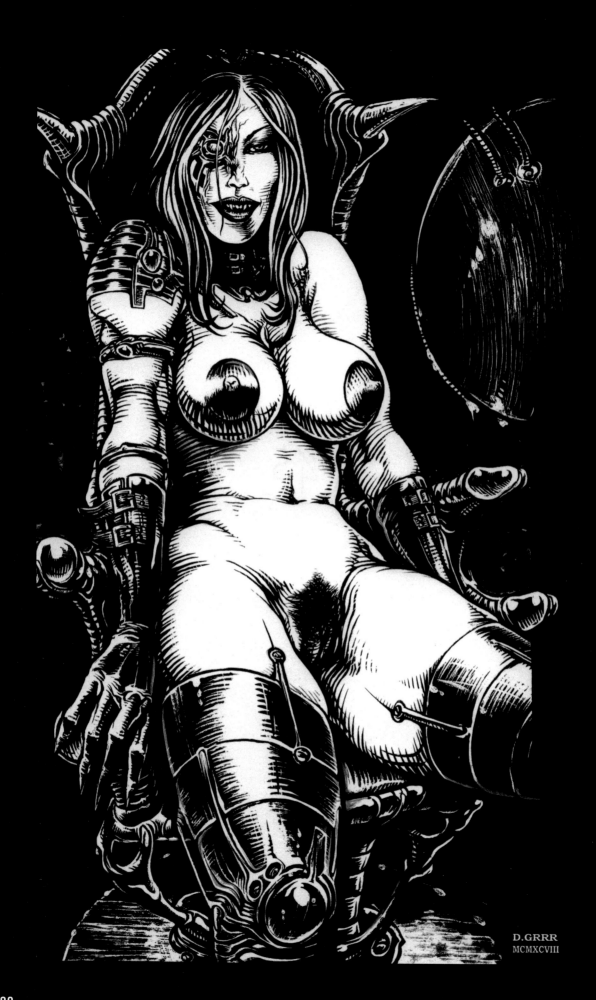

DENIS GRRR **Apocryphorgy**

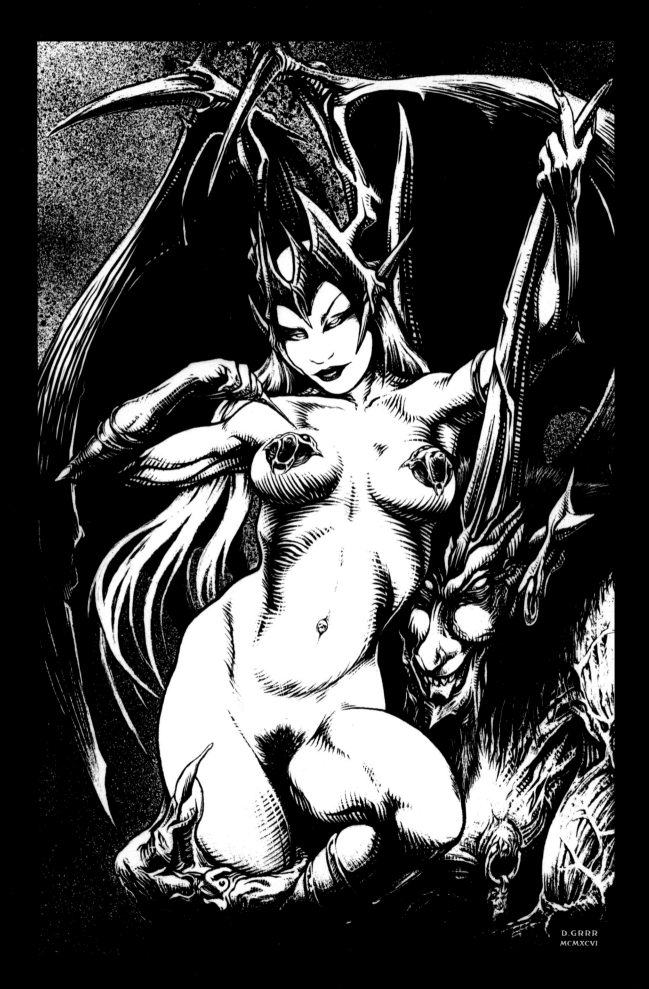

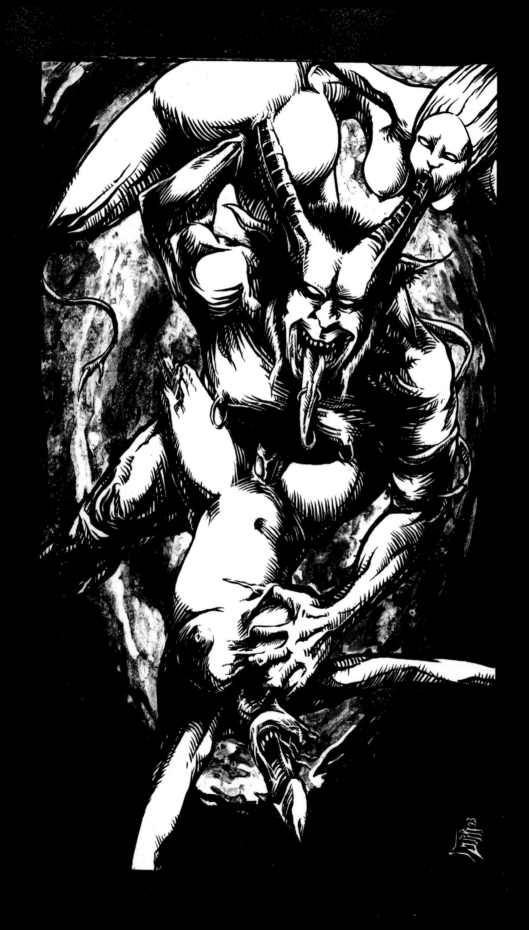

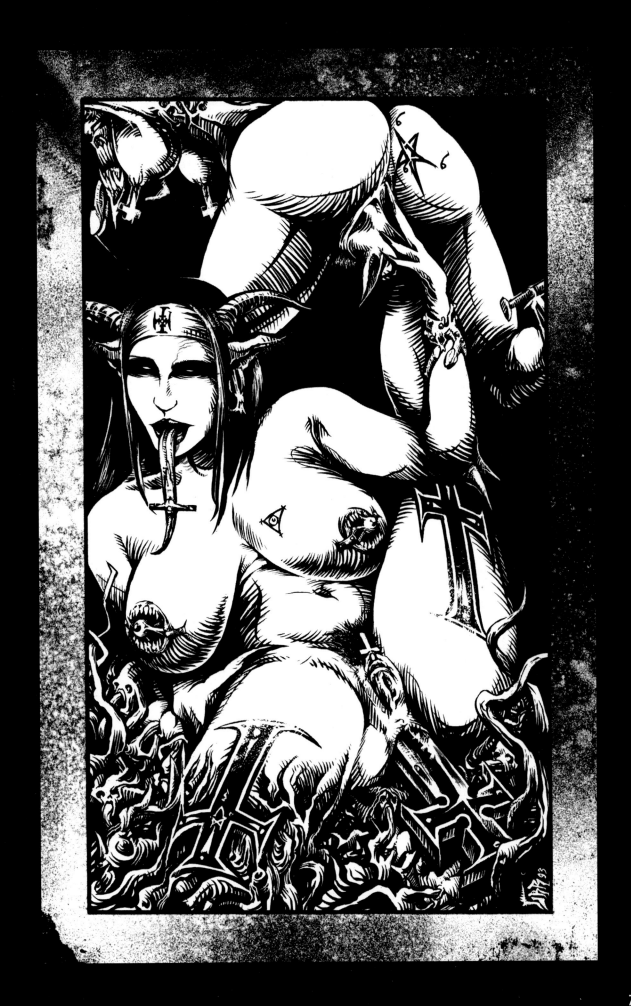

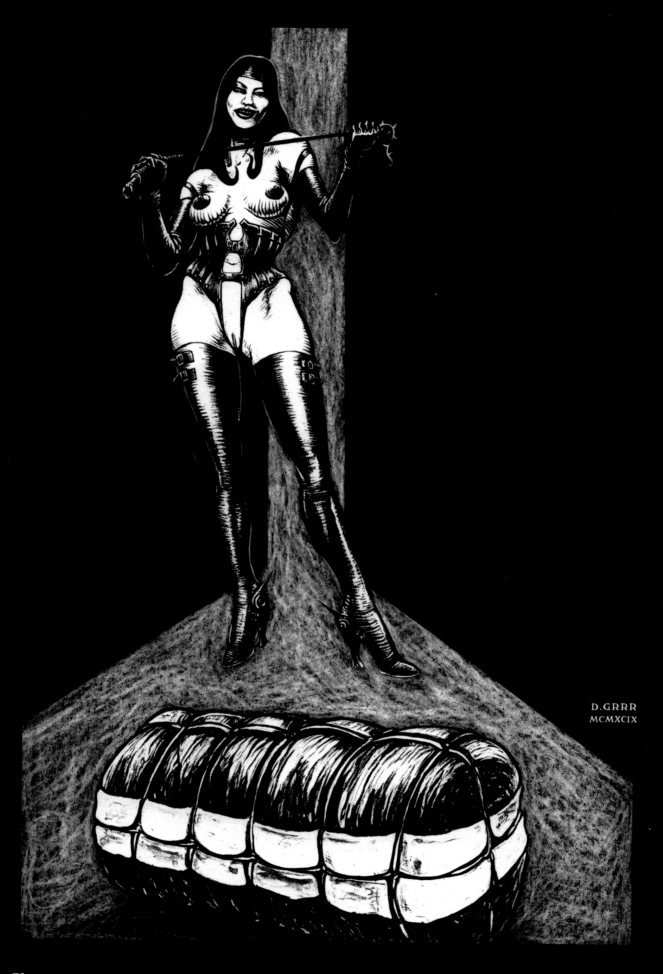

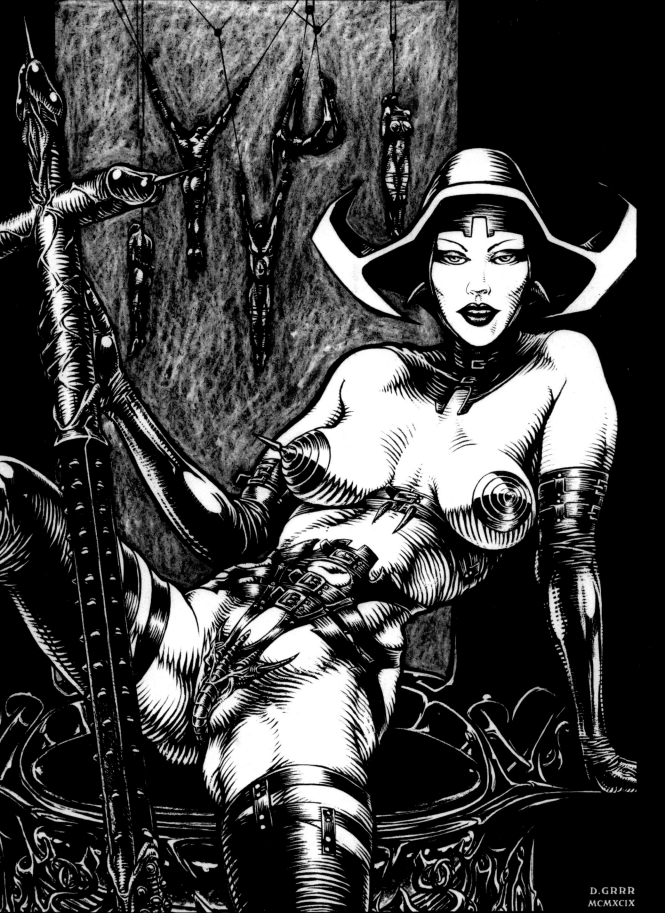

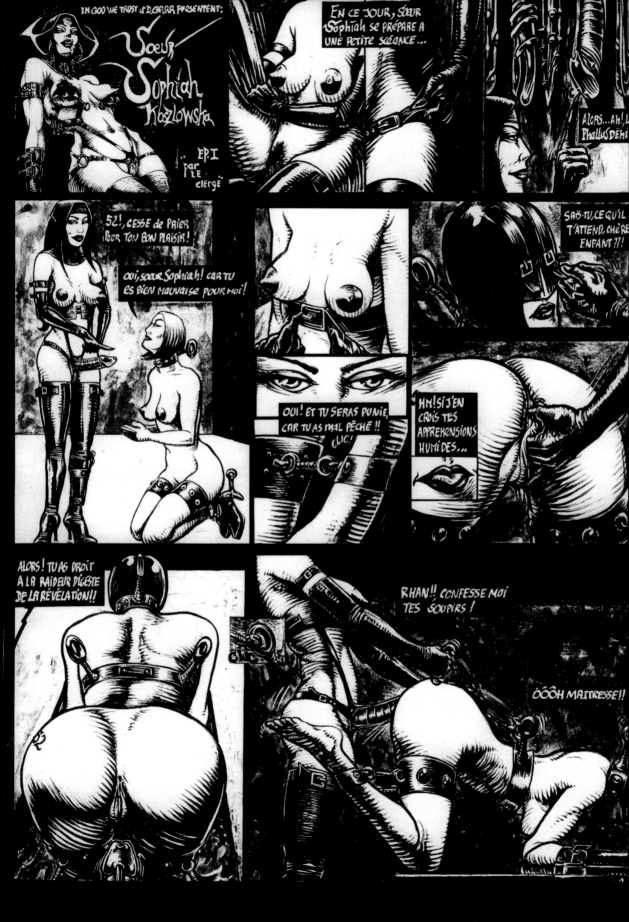

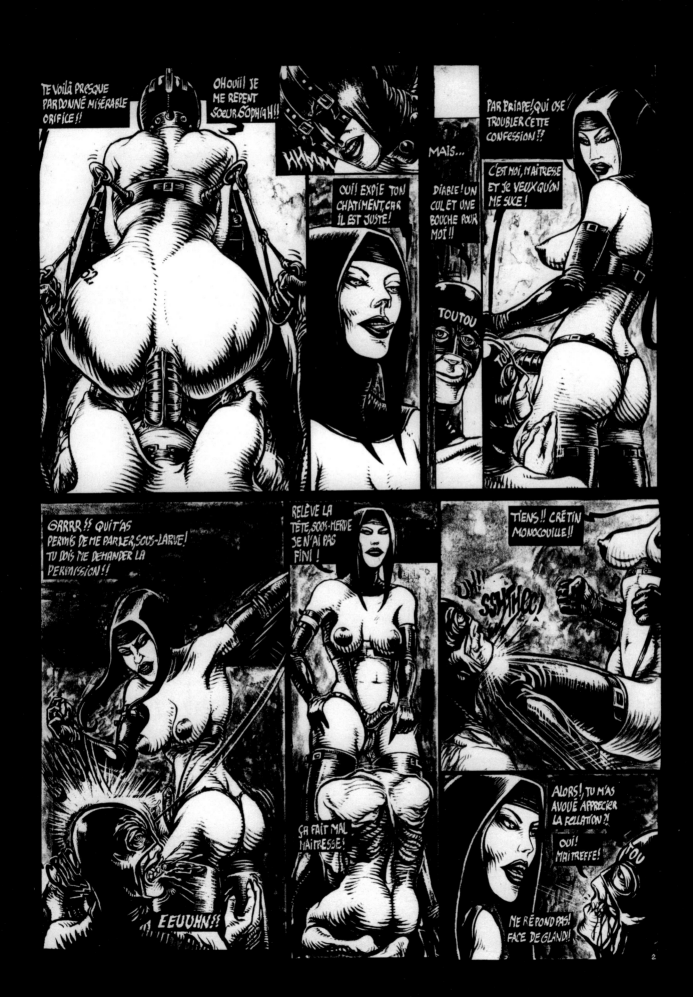

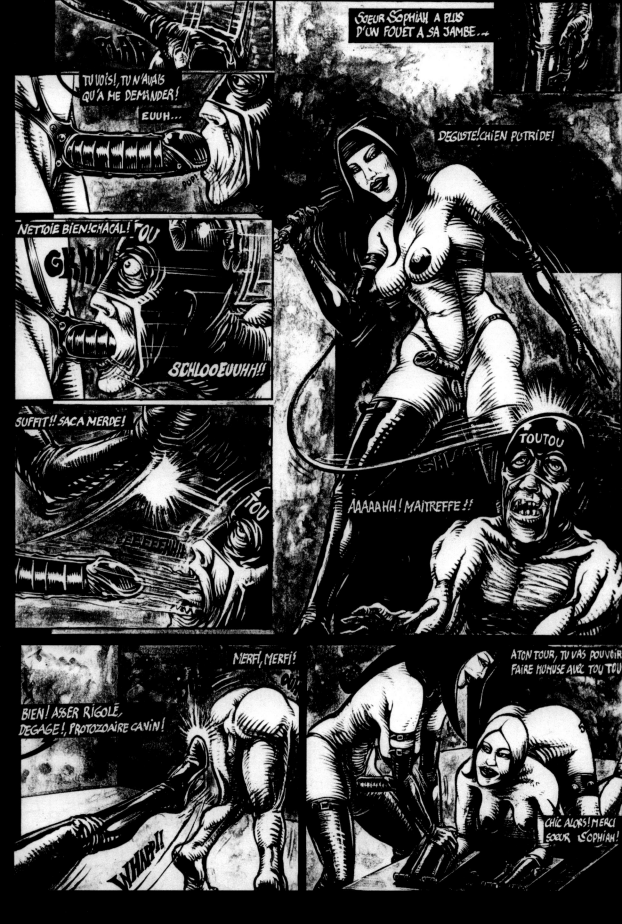

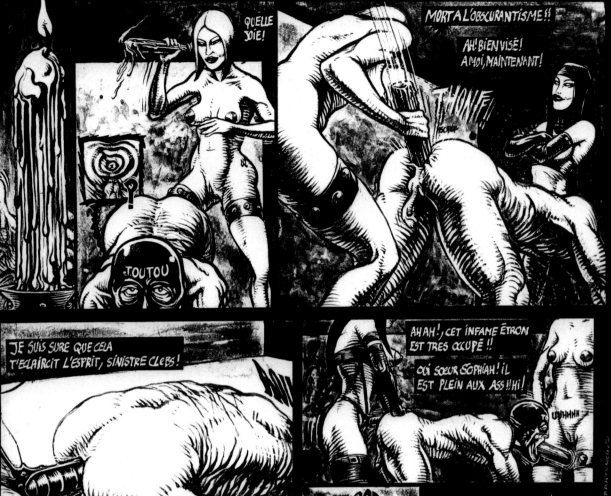
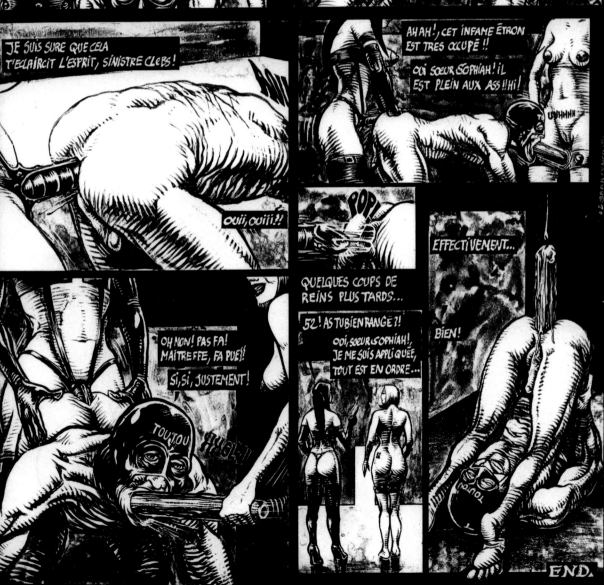

DENIS GRRR **Apocryphorgy**

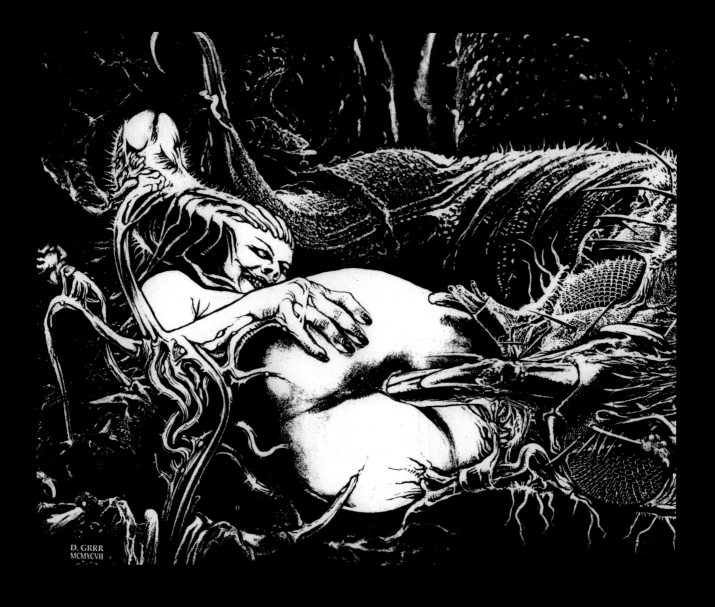

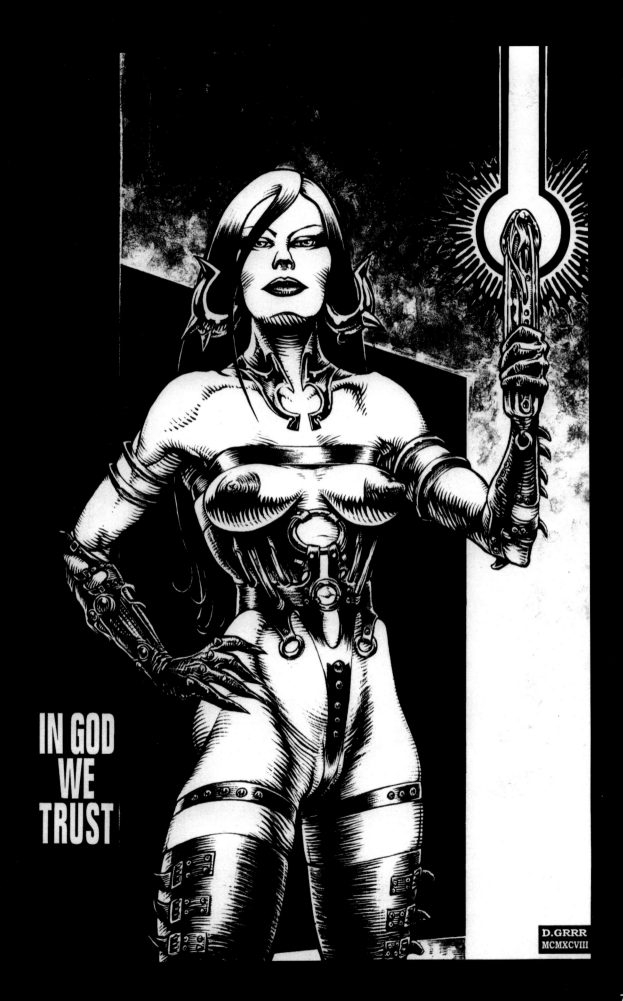

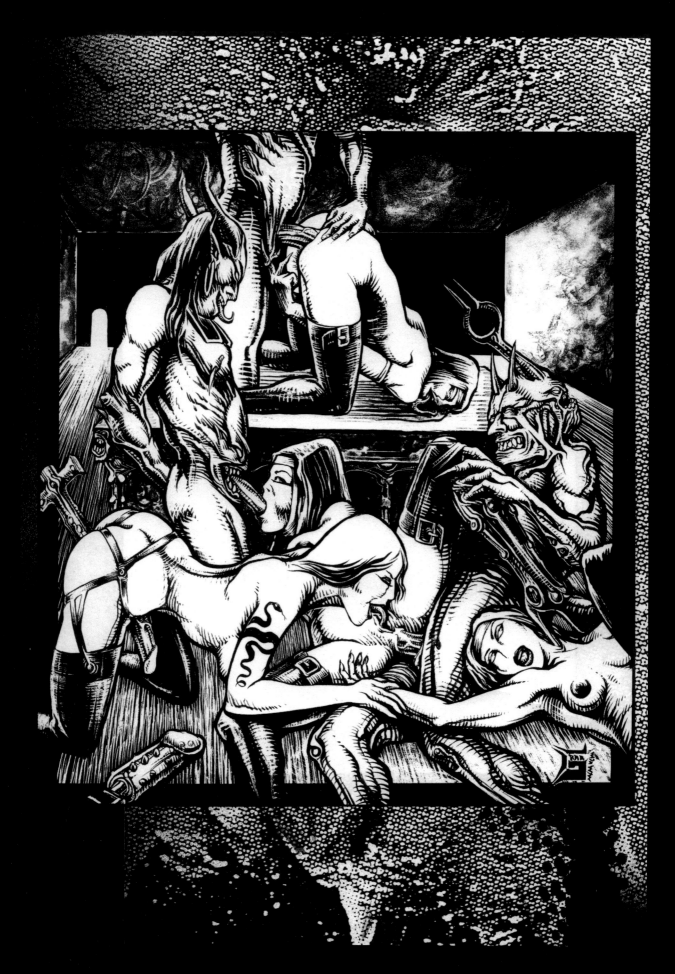

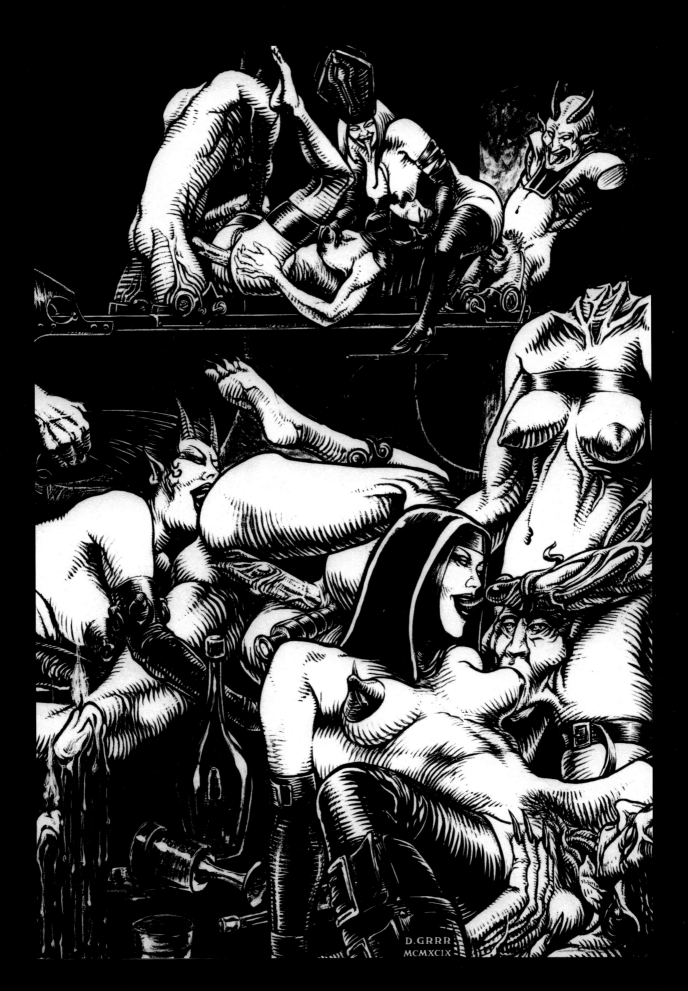

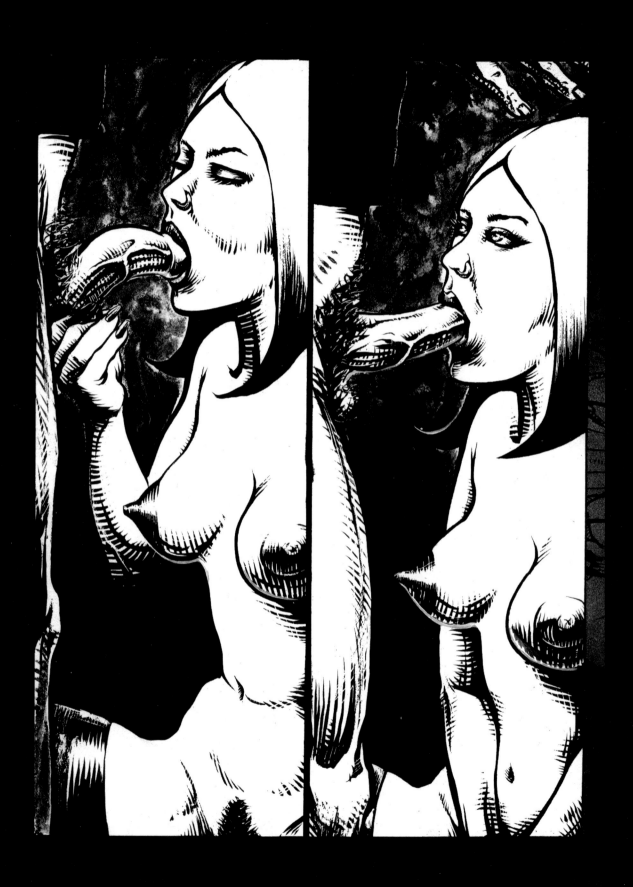

DENIS GRRR **Apocryphorgy**

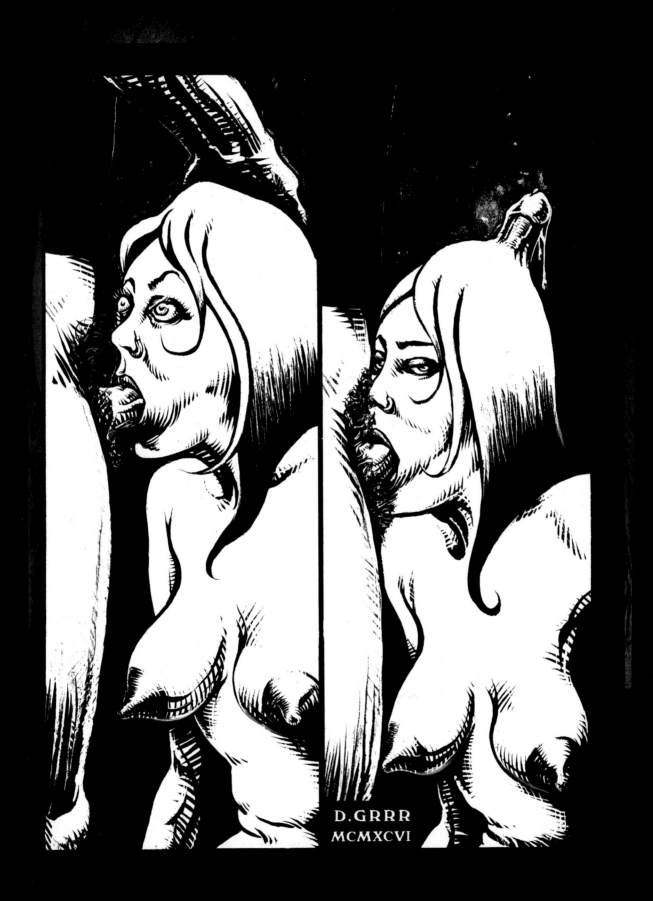

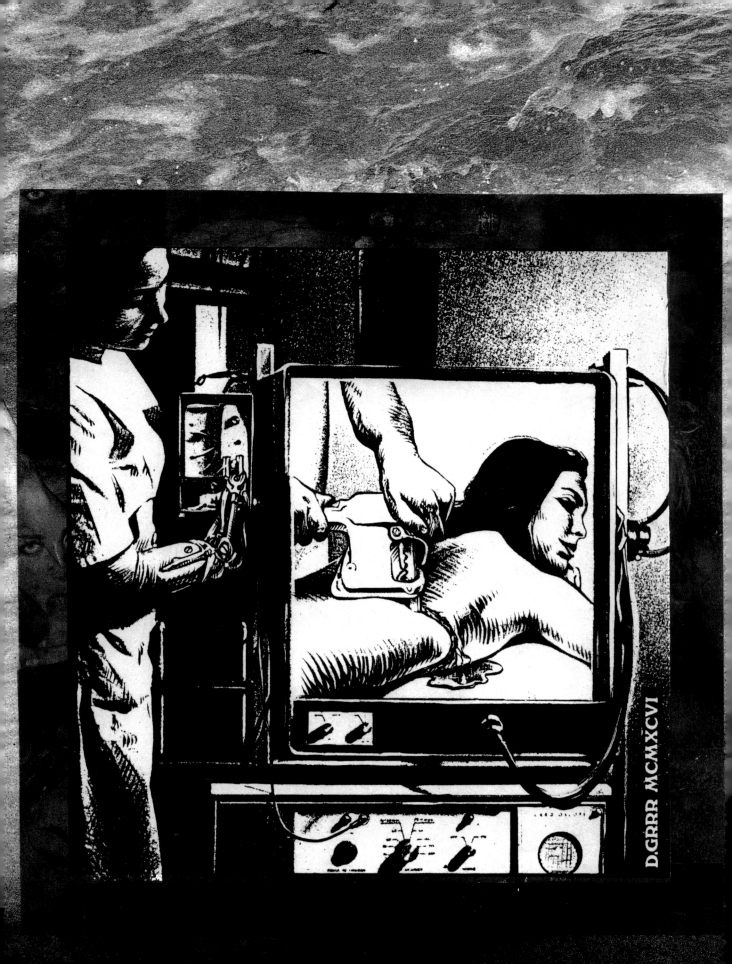

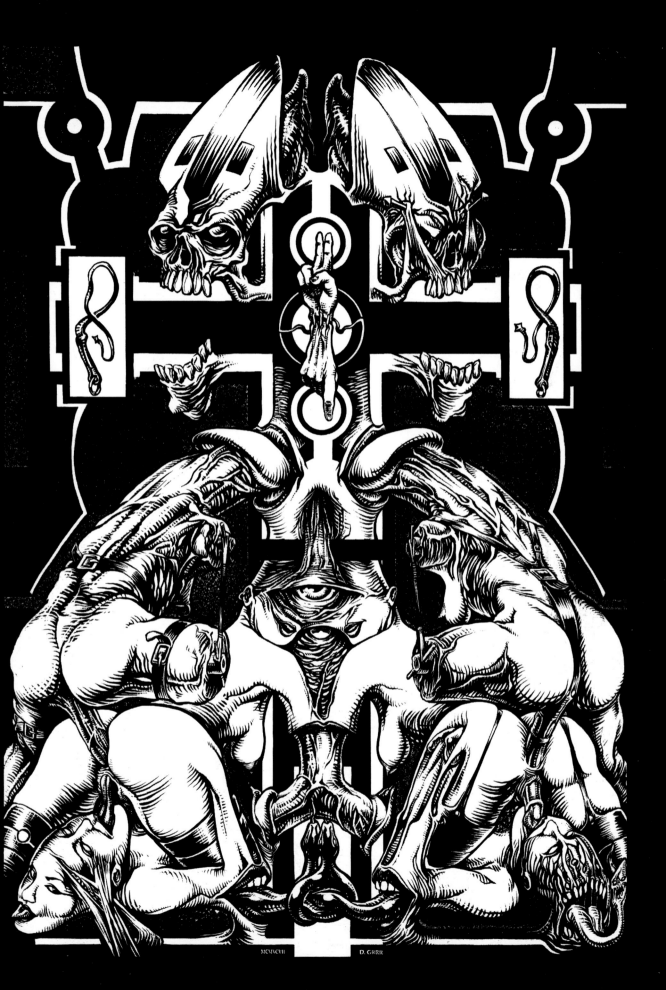

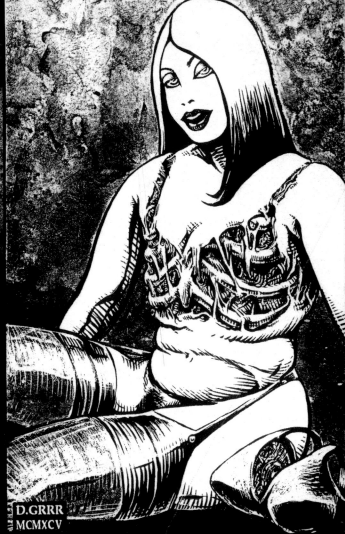

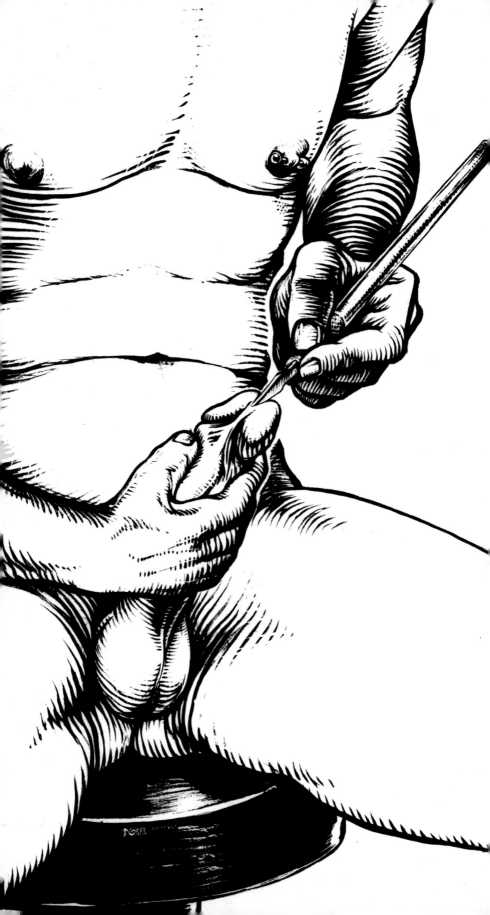

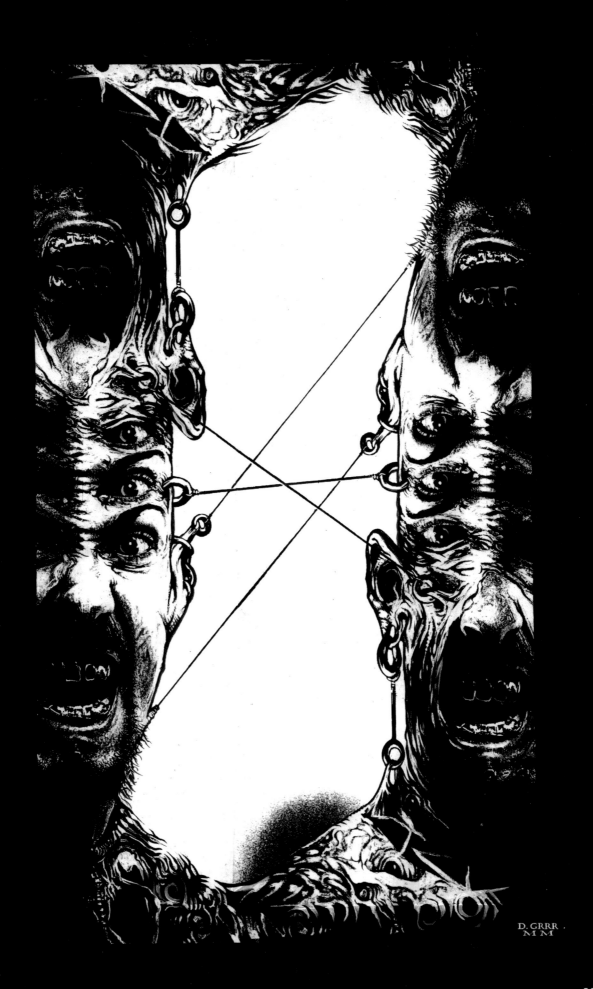

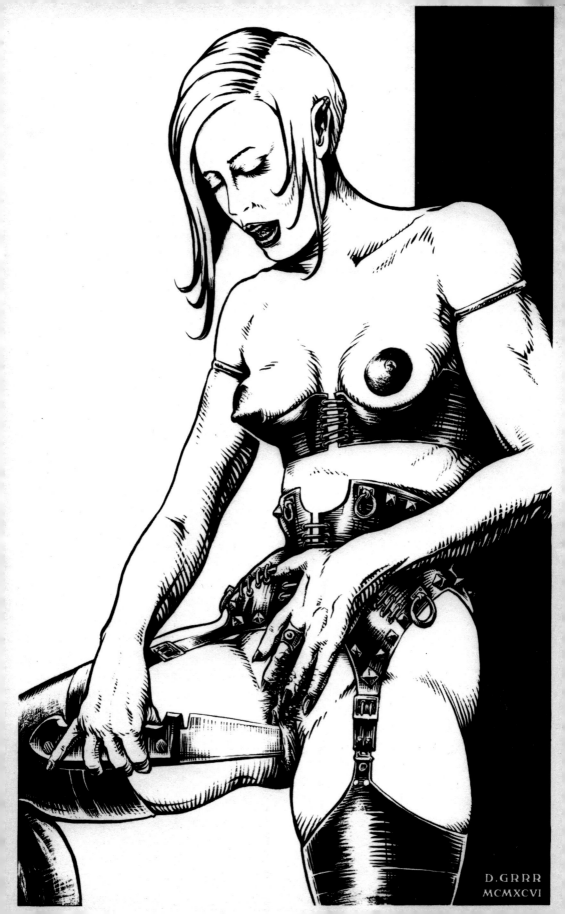

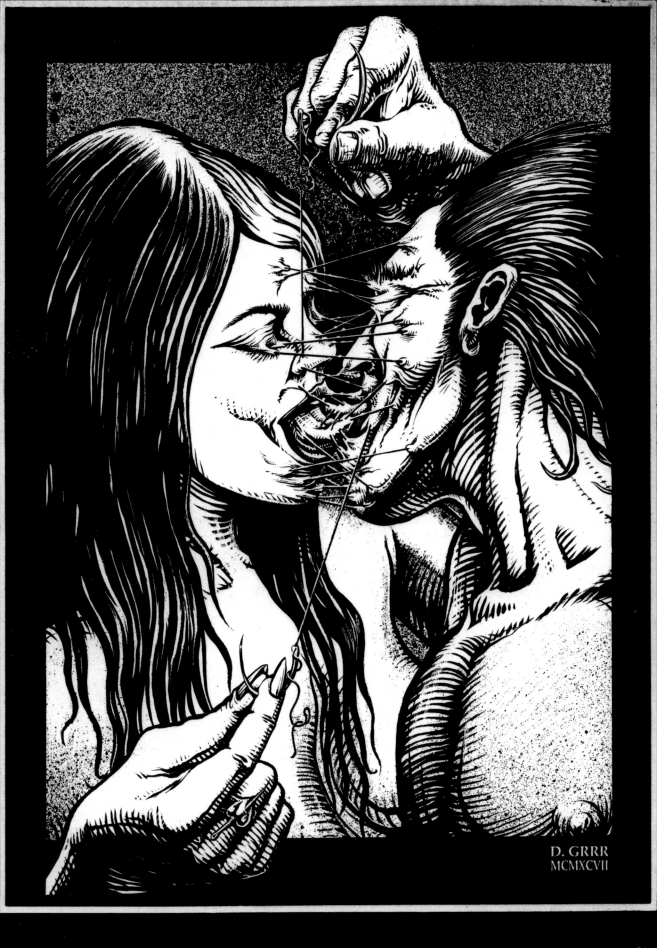

DENIS GRRR **Apocryphorgy**

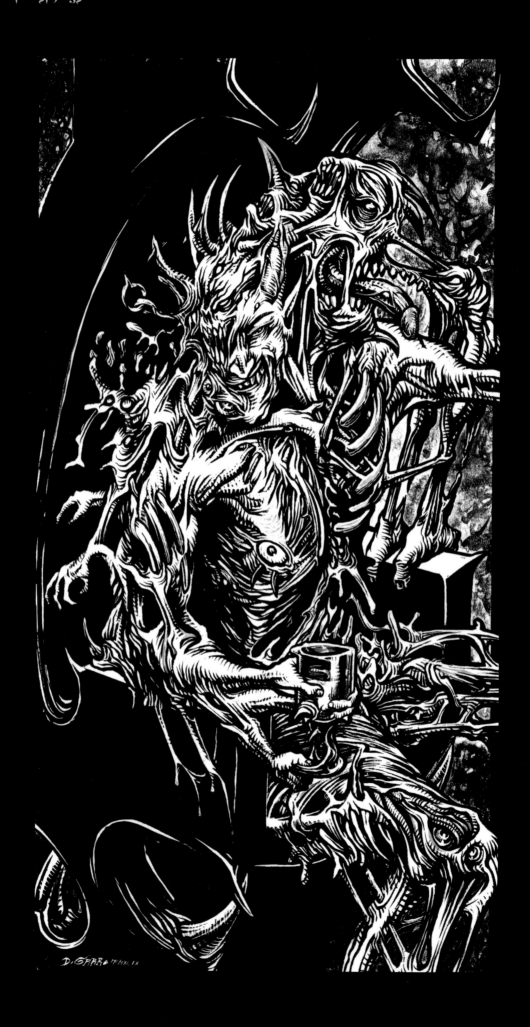

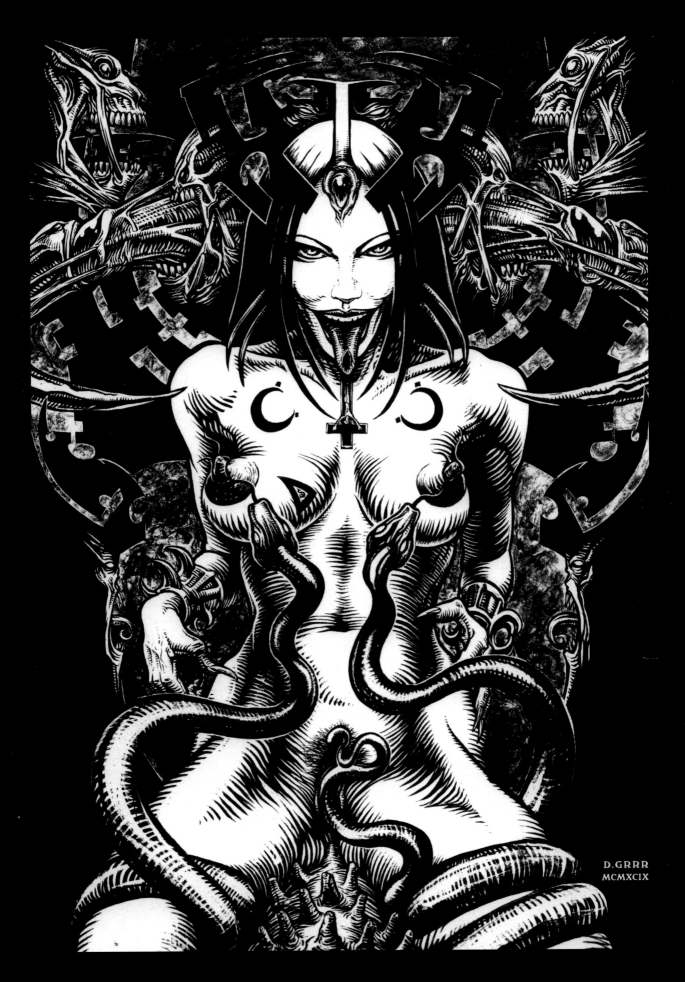

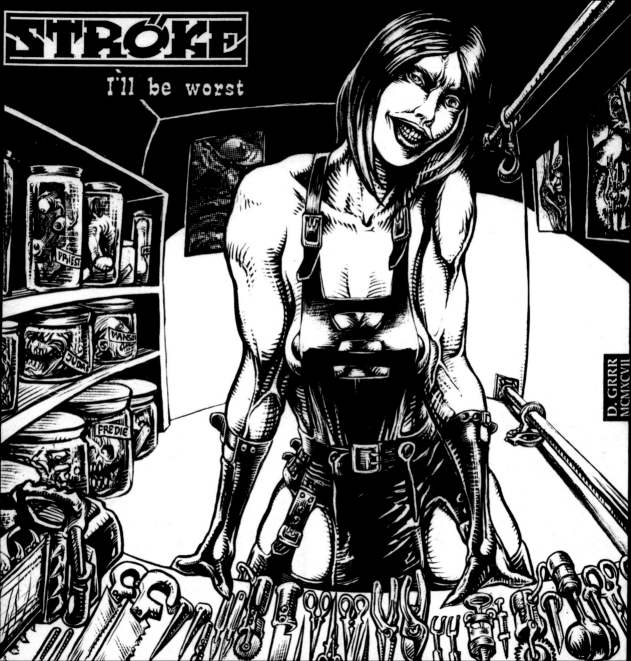

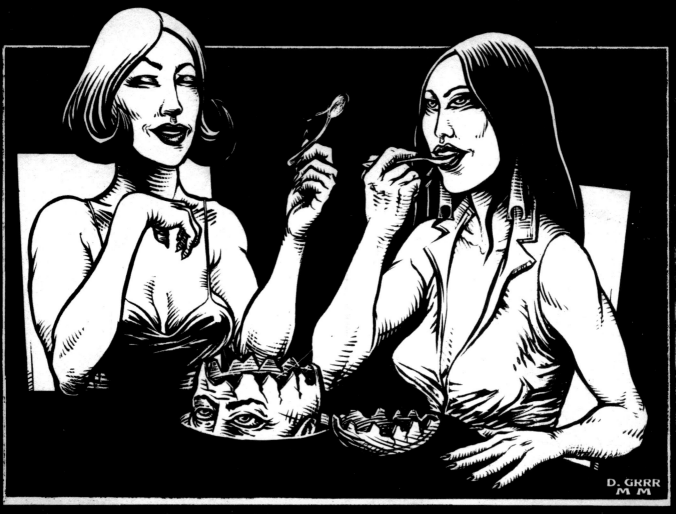

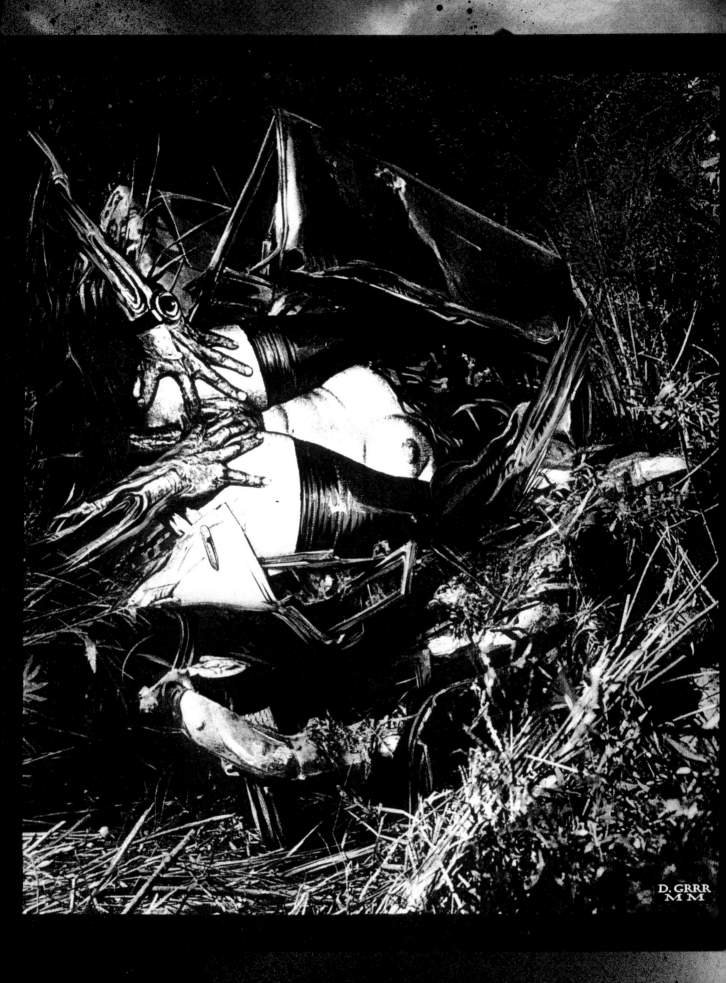

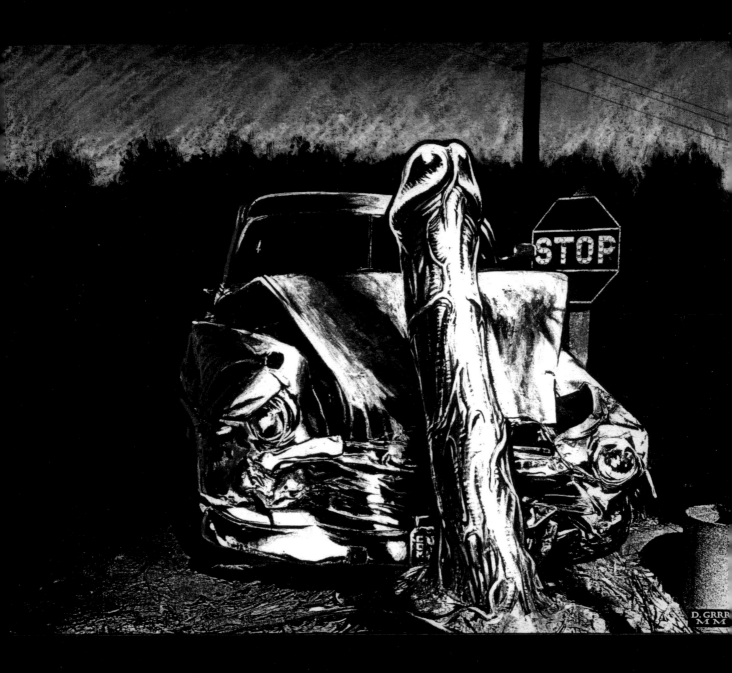

Copy No. 448/999